Between the Lakes: Artists Respond to Madison

Siah Armajani

Matthew Buckingham

Donna House

Lee Mingwei

Truman Lowe

Nancy Mladenoff

Alec Soth

Between the Lakes

Artists Respond to Madison

Organized by Stephen Fleischman and Jane Simon

Madison Museum of Contemporary Art

Major funding for *Between the Lakes: Artists Respond to Madison* has been provided by the Madison Community Foundation; the Webcrafters-Frautschi Foundation; the Madison Cultural Arts District; the Elizabeth Firestone Graham Foundation; the Miller Brewing Company; the Dane County Cultural Affairs Commission with additional funds from the Endres Manufacturing Company Foundation and the Overture Foundation; Associated Bank; Alliant Energy; AT&T; Chamberlain Research Consultants; the Madison Arts Commission; and the Terry Family Foundation. Additional support for *Between the Lakes* has been provided by Madison Trust of the Brittingham Fund; the Madison Concourse Hotel and Governor's Club; a grant from the Wisconsin Arts Board, with funds from the State of Wisconsin; and the Art League of the Madison Museum of Contemporary Art.

Catalogue of an exhibition held at the
Madison Museum of Contemporary Art (MMoCA)
227 State Street
Madison, Wisconsin
53703

April 23 through July 16, 2006

Includes bibliographical references

ISBN 0-913883-32-8

Library of Congress Cataloguing-in-
Publication Data

Editor: Stephen Robert Frankel, New York

Design: Glenn Suokko Inc., Woodstock, Vermont

Printing: Die Keure, Brugge, Belgium

Edition of 1500

Photography Credits
Matthew Buckingham: cover, 22
George Caswell: cover, 19, 45
Doug Fath © 2006 Madison Museum of Contemporary
 Art: 10, 16
Bruce Fritz: 9
Michael Kienitz: 31
Planet of the Apes © 1968 Twentieth Century Fox: 32
Alec Soth: cover, 21, 63, 65
James Wildeman: cover, 23, 25, 26, 42, 46, 48, 50, 53,
 55, 57, 59, 61
The Capital Times via www.Merlin-Net.com: 35, 36

For detailed information on the cover images
see pages 17–29.

Contents

Stephen Fleischman

Director's Foreword

This publication documents the Madison Museum of Contemporary Art's inaugural exhibition in its new facility within Overture Center for the Arts, an occasion that celebrates 105 years of the Madison community's involvement with, and support of, the Museum.

A brief history of the Museum: On April 1, 1901, a public meeting at the Wisconsin State Historical Society launched the Madison Art Association. In borrowed spaces, ranging from the public library to the University of Wisconsin's Memorial Union, the Art Association presented exhibitions, classes, and lectures by such luminaries as Alexander Archipenko, Le Corbusier, John Steuart Curry, and Frank Lloyd Wright. Art Association members spanned a broad cross section of area residents, including university faculty, prominent business people, and community volunteers. These early years are carefully documented by Janet Ela in her book *History of the Madison Art Association* (1951). Not until 1964 did the Art Association occupy its first home in the former Lincoln School on the shore of Lake Mendota. These heady years were marked by the continued evolution of this independent, nonprofit organization, which made the transition from a volunteer to a professional staff. During this fruitful period, the organization also adopted a new name, the Madison Art Center. A permanent collection was established and significantly shaped by the bequest in 1968 of more than one thousand works by collectors Rudolph and Louise Langer. (fig. 1 and 2)

In 1980, the Museum moved to its second home, a new space in the Madison Civic Center (an arts complex for both the performing arts and the fine arts), just two blocks away from the State Capitol building. The Museum's space in the Civic Center had been converted from a former Montgomery Ward & Co. department store and several other retail shops by the New York-

fig. 1
Early art classes at the Madison Art Association

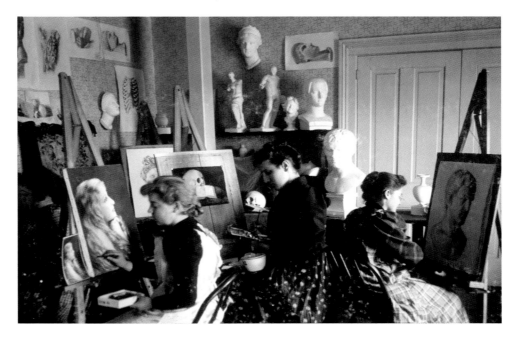

fig. 1
Early art classes at the Madison Art Association

fig. 2
Madison Art Center in the former Lincoln
School building, 1977

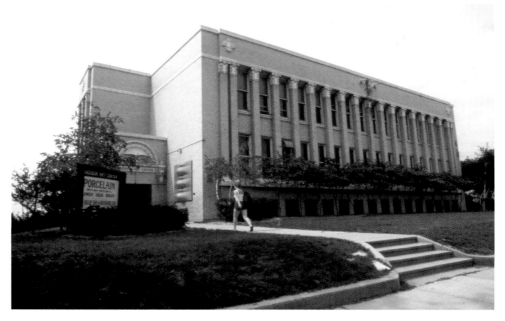

based architecture firm Hardy Holtzman Pfeiffer Associates. Although this downtown venue provided visitors with easy access, the Art Center's 27,000 square feet of total space was smaller than its prior home in the former Lincoln School. As Art Center offerings grew more ambitious in scale, it became clear that a larger building was necessary. Many of the Art Center's exhibitions were restricted by the size of the gallery space, its protruding balcony, and its inadequate weight-bearing capacity. Education programs, film presentations, and performances took place in a small auditorium with a flat floor and limited technical capability. Many basic museum features such as a lobby, an education classroom, and a loading dock did not exist in the Art Center. (fig. 3) Encouraged by several architectural studies and the acquisition of two adjacent properties, the museum investigated alternative expansion possibilities and sites for more than a decade.

W. Jerome Frautschi, a former Museum trustee and long-time friend of the arts in Madison, announced his plans for creating Overture Center for

the Arts in July 1998. His vision for a new performing and visual-arts complex would ultimately occupy a full city block and accommodate nine resident organizations, including the Madison Art Center. A needs assessment was spearheaded by community arts leaders, and an architectural search conducted by the Overture Foundation culminated in the hiring of Cesar Pelli & Associates of New Haven, Connecticut as design architects for the project. Cesar Pelli's considerable experience in both performing-arts and museum projects was a key factor in his firm's selection. Two noted Madison-based firms, Potter Lawson and Flad & Associates, formed a partnership to collaborate with Pelli Clarke Pelli Architects on the project, and J.H. Findorff & Son was selected as the construction manager. The museum staff and Board of Trustees, working with the Overture Foundation, consultants, and the architects, produced a written program to help guide the design of the Museum's new space.

The museum design that evolved comprises 51,500 square feet of interior space, and includes flexible galleries with high ceilings, a 230-seat lecture hall equipped for film, video, and computer presentations, a dedicated children's art-education classroom, a works-on-paper study center, a new-media gallery, an art library, and a conference room. The new design also incorporates critical features such as carpentry, photography and matting/framing workshops, administrative offices, a loading dock and freight elevator, and expanded art-storage facilities. A late addition to the project, recommended by museum consultants Martin and Mildred Friedman, was a rooftop restaurant and an adjacent 7,100-square-foot sculpture garden. Envisioned as a space for large-scale sculpture, the rooftop was also designed to accommodate outdoor film and video projections and serve as a community gathering space.

In 2001, construction began on Phase I of the project, which included the 2,250-seat Overture Hall, among other spaces. In order to ensure the success of the resident groups, a major endowment matching campaign—the Great Performance Fund—was initiated by the Pleasant T. Rowland Foundation and administered through the Madison Community Foundation. A generous community response allowed the fund to reach its goal in 2004. The Museum has subsequently engaged in fund-raising for its sculpture garden and a larger

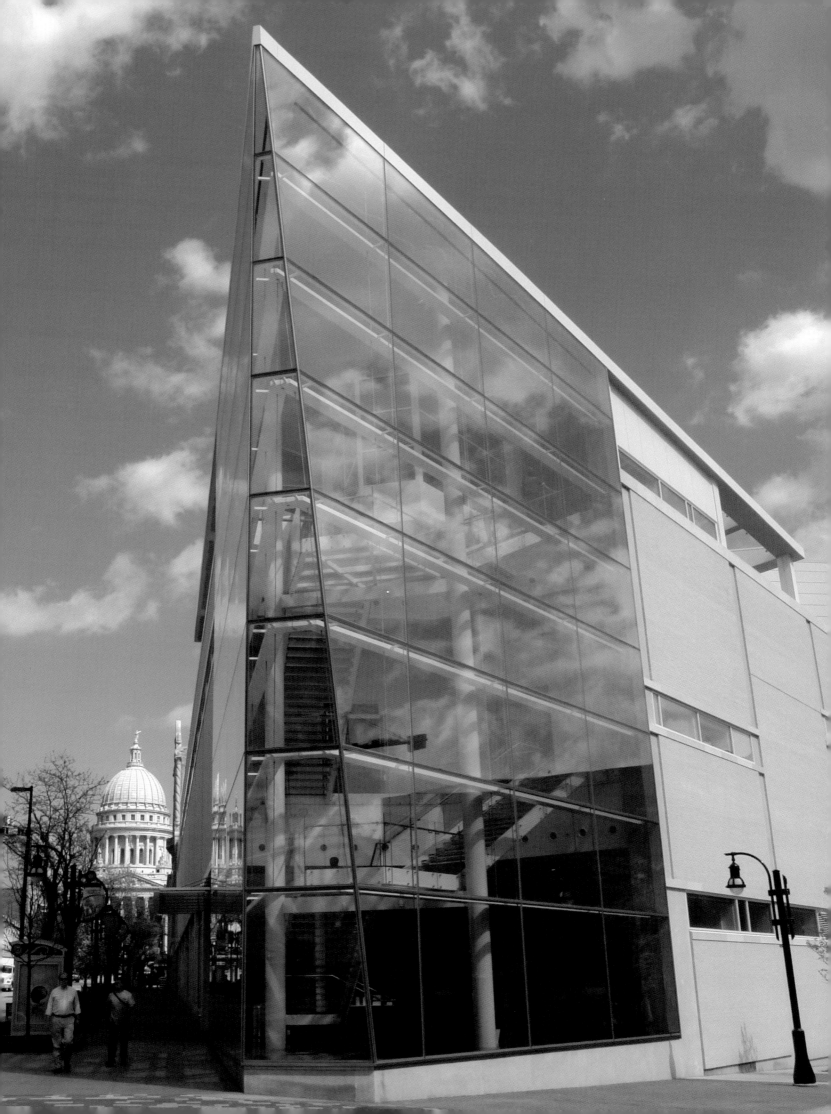

figs. 4 and 5
The new museum in the Overture Center for the Arts on State Street, 2006

endowment to support operations in this new facility. Phase I of building Overture Center of the Arts celebrated its completion in September 2004. The Madison Art Center closed its final exhibition in its old facility in early 2004 and had vacated the premises by March of that year.

The next two years offered an opportunity to present a series of off-site exhibitions and education programs under our institution's new name, Madison Museum of Contemporary Art (MMoCA). This name anticipated the organization's first facility specifically designed for the presentation, study, and preservation of modern and contemporary art. Demolition of the old building started in May 2004, and by January 2005 the new museum began to rise at the intersection of State, Johnson, and Henry streets. The Madison Museum of Contemporary Art features a sharply angled three-story glass atrium, located on one of the downtown area's many wedge-shaped parcels of land, which result from the city's radial street plan. The building echoes the flatiron expressions and scale of surrounding structures while incorporating a distinctly contemporary design sensibility, materials, and technology. The Museum, like the rest of Overture Center, offers a high degree of transparency to passersby with its extensive use of low-iron glass, yet maintains a highly controlled environment for works of art. (figs. 4 and 5)

The Museum is the final component of Overture Center for the Arts. MMoCA's opening in April 2006 also marked the sesquicentennial of the City of Madison. The inaugural exhibition, *Between the Lakes: Artists Respond to Madison* was conceived with this confluence in mind. The exhibition takes its inspiration from the city—past, present, and future—that has nurtured MMoCA and will continue to shape it in the years to come.

The exhibition consists of six new, commissioned works created by seven noted artists—Siah Armajani, Matthew Buckingham, Lee Mingwei, Nancy Mladenoff, Alec Soth, and a collaboration between Donna House and Truman Lowe—installed in MMoCA's 8,100-square-foot main galleries located on the second floor of the Museum.

The artists were asked to reflect on notable aspects of Madison and to use the city as a point of departure for their investigations. In their work, they have employed a wide range of working methods, mediums, and sensibilities. Siah Armajani's sculpture, which focuses on Ralph Waldo Emerson, encourages viewers to contemplate the city's role in hosting important academic, political, and intellectual figures. Matthew Buckingham's film installation examines how Madison schoolchildren learn about their environment, especially the region's geological underpinnings. Truman Lowe and Donna House's collaboration focuses on the area's natural environment. Lee Mingwei's work incorporates gifts from area residents that explore how the new museum will relate to its community. Nancy Mladenoff's paintings identify creatures and objects with strong connections to Madison. Photographs by Alec Soth pay homage to the region's tradition of fostering cooperatives, by documenting people living together in the Lothlorien co-op on Lake Mendota.

The Madison Museum of Contemporary Art has a distinguished history of working with artists to realize exhibitions and installations of new works. It seems particularly fitting that the inaugural exhibition in this building centers on the creation of new works. *Between the Lakes: Artists Respond to Madison* simultaneously carries on a tradition and launches a new phase of the Museum's innovative exhibition program.

Acknowledgements

This exhibition and catalogue have been made possible through the encouragement, dedication, and generosity of many people. First, we extend our sincere thanks to the artists themselves, who have been so generous with their ideas and insights—Siah Armajani, Matthew Buckingham, Donna House, Lee Mingwei, Truman Lowe, Nancy Mladenoff, and Alec Soth. At an important milestone in the history of Madison and of this institution, they have given us a unique perspective on the city and region, both past and present.

Several major contributors enabled the Madison Museum of Contemporary Art to undertake *Between the Lakes: Artists Respond to Madison,* and we are grateful to them all. Major funding for the exhibition and the catalogue have been provided by the Madison Community Foundation; the Webcrafters-Frautschi Foundation; the Madison Cultural Arts District; the Elizabeth Firestone Graham Foundation; the Miller Brewing Company; the Dane County Cultural Affairs Commission with additional funds from the Endres Manufacturing Company Foundation and the Overture Foundation; Associated Bank; Alliant Energy; AT&T; Chamberlain Research Consultants; the Madison Arts Commission; and the Terry Family Foundation. Additional support for *Between the Lakes* has been provided by Madison Trust of the Brittingham Fund; the Madison Concourse Hotel and Governor's Club; a grant from the Wisconsin Arts Board, with funds from the State of Wisconsin; and the Art League of the Madison Museum of Contemporary Art.

We offer our thanks to Katy Siegel for her thoughtful essay; we are sure that many people will relate to her experiences and her attachment to Madison. We would also like to thank Glenn Suokko for his elegant design of the catalogue and to Stephen Robert Frankel for his careful attention to detail as the editor. We would like to express our appreciation to the artists'

representatives for their assistance: Larry Shopmaker and Betsy Senior, at Senior and Shopmaker; Wendy Cooper, at Wendy Cooper Gallery; Lea Freid, at Lombard-Freid Projects; Janice Guy, at Murray Guy; Gagosian Gallery; and the Martin Weinstein Gallery. We thank MMoCA's Board of Trustees for their ongoing support and enthusiasm. Our thanks also to several staff members who have been instrumental in making this project come to life: Mark Verstegen and Dale Malner, former director and current director of technical services; Emily Schreiner, curatorial assistant; Doug Fath, preparator; Jennifer Holmes, assistant to the director; Sheri Castelnuovo, curator of education; Janet Laube, education associate; Marilyn Sohi, registrar; Nicole Allen, director of development; Katie Kazan, director of public information; and the Museum's entire staff and crew for their tireless work.

Our sincere gratitude to several members of the community who have been a tremendous resource in making this project possible: David Mollenhoff, Ann Waidelich, Kenneth J. Sacks, J.J. Murphy, Jill Casid, Tino Balio, Susan Cook, Kate Hewson, and Cara O'Connor.

Our most profound thanks go to W. Jerome Frautschi. His commitment to build the Overture Center for the Arts, including the new Madison Museum of Contemporary Art, have enabled us to present *Between the Lakes* here in this wonderful facility, and will provide a magnificent setting for the exhibitions that will follow in the decades to come.

Stephen Fleischman
Director

Jane Simon
Curator of Exhibitions

Jane Simon

Between the Lakes: Artists Respond to Madison

We cannot say for sure why people came to this site thousands of years ago and settled on this isthmus between two lakes. We cannot say for sure why they created the numerous effigy mounds scattered around this landscape. But, we can imagine that the motivation for these effigy mounds was the beauty of this area. Madison boasts more effigy mounds than any other city in the world. Divided into three categories—earth, water, and sky—these earthen sculptures are a powerful vestige of a culture no longer in existence but thought to be the precursor to the contemporary Ho-Chunk tribe. Because the mounds exist without the usual written record we use to formulate history, they remain a mystery to us, but we can also understand that the culture that created them attached spiritual significance to the schematic images of bears, panthers, geese, and turtles. And, because they are placed so specifically in relationship to the lakes—providing awesome views of the water, tree tops, and the organic coastline—we can imagine that the beauty of this landscape seduced these first immigrants.

Attorney James Duane Doty was also captivated by the beauty of this site. Doty, a circuit-court judge who had made a name for himself in the rambunctious politics of what was then the western edge of the country, had a vision for the land between lakes Mendota and Monona. Instrumental in defining the Wisconsin Territory, Doty was also responsible for drawing up the plans for cities such as Green Bay and Fond du Lac before turning his attention to Madison in the 1830s.[1] Doty's enthusiasm for this site convinced the legislators at the Belmont congress of 1836 that this narrow stretch between two glacial lakes should be the capital of the Wisconsin Territory and, later, of the state of Wisconsin. For Madison, Doty chose the radial plan, because he believed that such a site would facilitate the existence of a grand city. By nam-

ing the city "Madison," Doty tapped into the emerging sentiment for the recently deceased former president James Madison and harnessed the allure of his favorite Washington hostess, Dolley Madison.[2]

As Madison developed as a city—in a sense fulfilling Doty's dream—the importance of this aesthetic gift was not lost or even buried. In fact, the need and desire to preserve and hone this beauty became a guiding force in the politics and development of the city. The tension between industrialization and the need to protect the natural landscape affected many of the developments in the city, from restructuring ice production to cultivating Madison as a resort town. This progressivism—from its earliest manifestations in the political party of Robert M. La Follette to the radical political organizations of the tumultuous era of the 1960s—would come to define the reputation of this midwestern city.

Today, Madison is poised for the twenty-first century. The newly finished Overture Center for the Arts promises to become the cornerstone of a growing and vibrant arts community (fig. 6). This optimism for the future and appreciation of the past were the premises for *Between the Lakes: Artists Respond to Madison*. Taking a cue from the many exhibitions for which artists are asked to make new work for a given event or a given site, we extended such an invitation to seven artists who we were sure would see the forest for the trees.[3] We provided them with possible points of departure for the commissioned works—the preponderance Madison's numerous effigy mounds, the importance of the Progressive Movement's surge in the early twentieth century, the mystery of Otis Redding's plane crashing into Lake Monona, which they were free to use or to ignore, as they saw fit—and we were surprised and delighted with the results. All the works that they created reveal a depth of insight and individuality of expression that fulfilled our expectations for this exhibition and the unusual opportunity that it represents.

Several prevailing themes have surfaced among these six projects. The history of civic politics in Madison is a layered and forward-thinking one. Three of the artists who created works for the exhibition—Siah Armajani, Alec Soth, and Matthew Buckingham—investigate ideas and systems that have expressed Madison's liberal edge. Like Doty's vision of this beautiful site, the natural virtues of this area are a consistent theme in the exhibition. The paintings of Nancy Mladenoff and the collaboration between Truman Lowe and Donna House explore the details of our natural environment, and explain that it is central to life in Madison and to its colorful past. Finally, Lee Mingwei has probed beyond the white walls of the gallery to muse on the role of the museum in the larger Madison community.

Minneapolis-based Siah Armajani has long been interested in the democratic foundations of the United States and describes himself as a "midwestern populist."[4] Raised in shah-ruled Persia, the adolescent Armajani was introduced to American thinking by a teacher who encouraged him to read the writings of Ralph Waldo Emerson, because Emerson had translated a Sufi poet from German into English. From this base, Armajani has cultivated a life-long interest in the American-bred ideals of democracy and populism. These ideas, articulated during the nineteenth century by Emerson, centered on giving opportunities to everyone to enjoy, appreciate, and experience nature

and art. Starting in the late 1960s and continuing to this day, Armajani has created public works of art that also serve a civic function in cities and other communities around the world. To express this idea in the work he has made for *Between the Lakes*, he has incorporated a passage from Emerson's essay "Art" into the sculptural installation (abbreviated here): "Genius . . . is . . . to find beauty and holiness in new and necessary facts, in the field and the roadside, in the shop and the mill."[5] Armajani seems to have taken Emerson's dictum quite seriously by insisting that art be everywhere and for everyone. For example, his large public project called the *Irene Whitney Hixon Bridge* (1988) (fig. 7) provides the citizens of Minneapolis with pedestrian access from Loring Park to the sculpture garden of the Walker Art Center. Spanning the width of sixteen lanes of streets and highways, the piece alleviates the ravaging effects of winter in Minneapolis with its soothing baby blue and warm yellow hues. A poem by John Ashbery, commissioned by Armajani to run across the upper lintel of the bridge in each direction, evokes the wonder of everyday life in relation to the themes of movement, place, order, and crossing.[6]

For *Between the Lakes*, Armajani has created a sculptural installation exploring one of his favorite subjects, Emerson, who, during one of his many lecture tours, traveled to Wisconsin and addressed the state legislature on February 23, 1860. This piece is about Emerson's ideas and the legacy of his ideas: it addresses the tenets of Emerson's teachings regarding nature, man, and life, and visualizes for us the influence of Emersonian ideals in the progressive land of Wisconsin. (fig. 8; cat. nos. 1 and 2)

Entitled *Emerson's Parlor,* the work is a wood and glass structure that is T-shaped in plan, enclosing several different spaces. The biggest of the spaces—the stem of the T—contains several pieces of a puzzle, including a slender coffin on a large wooden table, a small model of a white house, and a bare metal bed frame. A wooden stairway in this space leads to a loftlike structure at the base of the T, in which Armajani has placed another metal bed frame, supporting a thin mattress folded in half and a pillow, with only a few inches between them and the space's glass ceiling. Just below this "sleeping loft" is a small room, the three walls of which are constructed of white-painted wood; opposite the fourth wall—which is part of the glass enclosure—the surface of the wooden wall is emblazoned with the aforementioned excerpt from Emerson's essay on art, executed in black paint. This room's glass wall has a door that is barricaded and a black felt curtain on the outside, which, when closed, conceals the Emerson text. Flanking the other end of the structure's biggest space, and forming the top of the T, are two additional rooms. One is opaque, with black panels and black beams, while the other contains a diamond-shaped shaving mirror and a scarecrow dressed in a men's formal coat and a gray hat from the 1930s, with sprigs of wheat emerging from the coat sleeves.

The presence of the coffin refers to Emerson's teachings and his own life. As a young man, Emerson's first wife, Ellen, had fallen ill to tuberculosis and died shortly after they were married in 1832. Soon after, Emerson visited her tomb and, while paying his respects, opened the vault and the coffin to see and experience firsthand her lifeless body.[7] This singular act of unconventionality and daring curiosity would come to be characteristic of Emerson, and coincided with his abdication of the pulpit in favor of becoming

a man of ideas. In Emerson's essay "Spiritual Laws," he writes about what we can learn from ruminating about death. Referring to the corpse, Emerson calls it a "solemn ornament to the house,"[8] which becomes a powerful allusion in Armajani's houselike sculpture. Here, Armajani combines signs of Emerson's own life with physical manifestations of his teachings. The minimal nature of the sculpture represents purity and simplicity, just as the transparency of the glass (when not covered over) facilitates the viewer's communion with the ideas enveloped by the architectural structure. The play between accessibility and inaccessibility further relates to our changing relationship to Emerson's ideas.

Placed on top of the simple coffin is a small model of a white house with a black roof. Reminiscent of Emerson's Old Manse, where Emerson lived when Ellen died, the miniature house is also an allusion to Victor Hugo's house on the island of Guernsey, which Hugo occupied when he was in exile before the French Revolution.[9] Exile is a familiar condition to Armajani, who left his native country as a young man and has only recently returned.[10] In addition, exile suggests a phantom sense of people, places, and culture, where only fleeting senses of the past are experienced and where a sense of being a stranger in the new land emerges. Armajani explains that Alberto Giacometti's *The Palace at 4 a.m.*, a work famous because of a photograph that Man Ray took of it

fig. 8
Siah Armajani, *Emerson's Parlor*, 2006

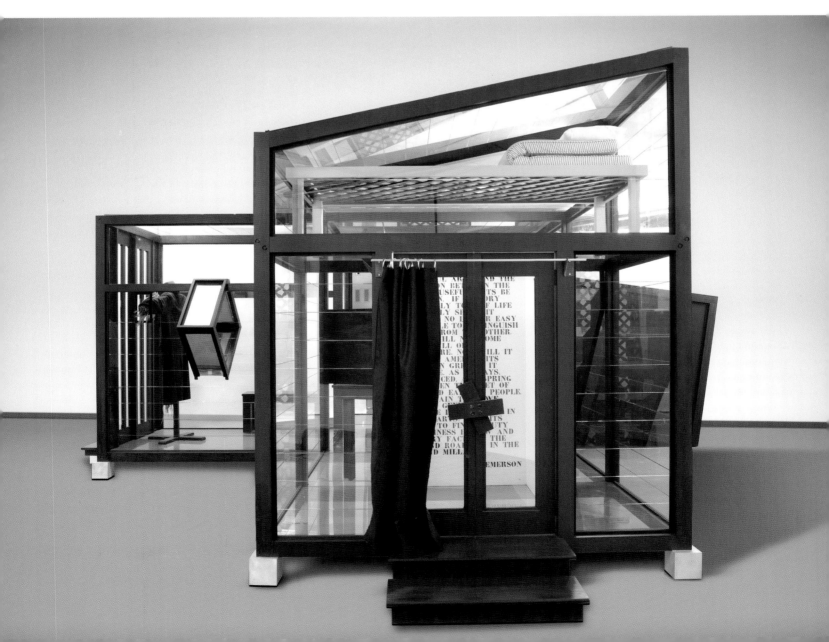

in 1932, has been a tremendous influence on him.[11] Although this Giacometti sculpture is often linked with the notion of the artist working alone in his studio, it departs from traditional sculpture in its use of freestanding figures as part of a larger architectural space.[12] As a large sculptural sketch, *Emerson's Parlor* also evokes, through multiple symbols, Armajani's own relationship to Emerson—or, more accurately, the figure of Emerson, who has been integral to his thinking as an artist but never wholly accessible.[13] In summary, Armajani uses one event as a point of departure to express the legacy of Emerson the man and his ideas.

Another artist based in the Twin Cities, Alec Soth, is also interested in the progressive undercurrent of Madison. Instead of being interested in the formation of progressivism that permeates the city's history, Soth looks to the living examples of this liberal thinking in the city. Since the birth of a counter-culture in the 1960s, Madison has harbored several housing cooperatives. Structured to share resources, ideas, and costs, these houses continue to be home to people who question the normative sexual and consumptive tropes of American life. By focusing on this housing movement in Madison, Soth brings attention to the various political groups that abound in the city and their common ideals. For *Between the Lakes*, Soth focuses on Lothlorien, one of approximately twenty cooperatives in Madison. This co-op occupies a Tudor-style building on Lake Mendota that was once the Dover House (a women's dormitory) and later the Phi Sigma Delta fraternity house. It can house up to thirty people, making it one of the largest co-ops in the city. Clothing is optional, and people of all ages, races, creeds, cultures, and sexual orientations can live there, with each person required to make a nine-month commitment. These people share their lives, space, nourishment, and social time, making the house an experiment in a utopian form of living.

To take his photographs, Soth uses a large 8x10 format camera. While preparing each shot, he stands with his head under a cloth and makes endless adjustments. During this seeming eternity, the subject has a chance to unwind, and eventually becomes unusually comfortable in front of the camera. Although the members of Lothlorien were open to Soth's project, the photographs are more the focus of his own particular curiosity than a reflection of their ideas about living, and filter the subjects' points of view through his perceptions about how they live.[14] His carefully composed photographs of people and places are lush, sensual, and insightful. For example, the photograph of Stephen, shot by the lake, emphasizes Stephen's white skin and pearlike silhouette, making a sharp contrast to the fertile summer foliage behind him, and he seems proud that he can show us his bare torso and where he lives. His pose, struck in defiance of societal ideals of humility, hints at the political beliefs that might have led to his living at the co-op. In another photograph, Anna, standing on the stairwell of the house, has been captured in a more private moment. (fig. 9) Casually sporting a red bathrobe and with her hair slightly tousled, this woman seems to wonder what this photograph might mean and what this encounter might signify. The gaze that Soth has recorded and the contingency of the circumstance are not intended to make us doubt her belief in the way she lives, but rather to understand the quizzical nature of this moment.

Glyphia, another picture in this series, invites us to stare at the eyes, nose, and evenly shaped mouth of another Lothian. (cat. no. 11) The slight turn of

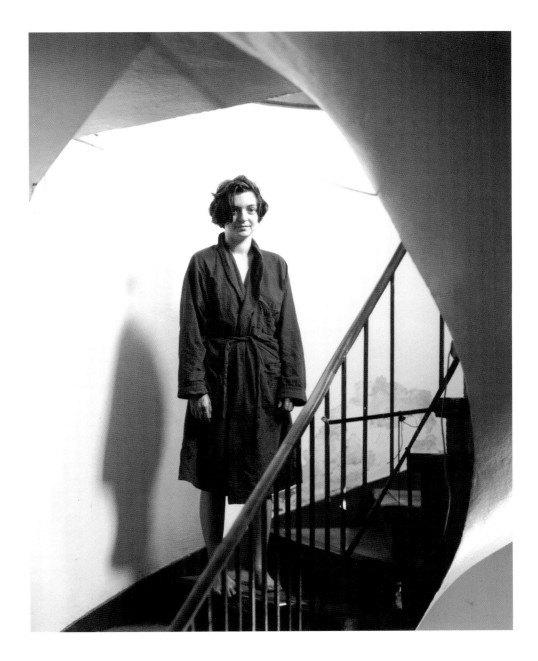

her head is reminiscent of a figure in a painting by Johannes Vermeer, among other art-historical references, but her intensity is what is most striking. Although her unconventional hairstyle is an indication of her liberal-mindedness, what matters more is the way she looks at us, which gives us a glimpse of her enormous humanity. Even though this woman must have some carefully calculated political and social beliefs, those ideas and ideals take a back seat to the access we have to her strength and vulnerability in the picture.

Not all the pictures show people. Four of the images are of Lake Mendota. Bordered by a lovely growth of vegetation, the path to the lake from the house is tunnel-like (cat. no. 12). Soth shows us a wooden pier at the lake's edge at the end of this passageway, at four different times of day taken over a period of five days. With this mental image of the coolness of the fresh water, it is easy to think of why Doty wanted a beautiful city to evolve here—or why, since the 1800s, Madisonians have wanted to keep this lake clean. It also reminds us of what groups like Lothlorien, or others, might need to do in the future to save this glacial vestige. In the end, even if Soth was drawn to the political foundation of this city and its liberal-minded people,

fig. 10
Matthew Buckingham, *Behind the Terminal
Moraine,* 2006

the photographs are not just about politics. Rather, they prove to us that by looking, and looking again, we might able to see.

All of us learn at school about our surroundings, our environment; we learn how rocks are formed over time by the abrasion of running water and that the American Revolution in the late 1700s gave birth to our nation. Like Armajani and Soth, Matthew Buckingham is fascinated by the legacy of progressivism in Madison. To be specific, he is interested in how Madison's government, which during the late 1940s spent 43 cents of every dollar on education,[15] teaches children about this place and its past. Buckingham's film installation *Behind the Terminal Moraine* tells the tale of Madison's dramatic geological past and our complicated relationship to this terrain. (cat. nos. 3 and 4) The title itself signifies that there is both a literal and a metaphorical meaning in our understanding of the past. A terminal moraine is a geological term referring to the deposits left by a retreating glacier that discards certain materials as it melts and changes shape. Madison's geology and its landscape, most evidently the lakes, are the effect of one such terminal moraine that left this area 24,000 years ago.[16] Like many of Buckingham's film projects, the piece uncovers not only the facts to be known about this place or but the apparatus that has shaped our understanding.

For Buckingham, the history of Madison does not begin in 1836 when it was declared the capital or in 1856 when it was chartered as a city. Slowly oscillating images of the isthmus at the center of the city makes us think about the original parameters of this site that were defined by Native Americans who lived here and called this area *taychopera*, the land of four

lakes. Interspersed with the changing images of lakes suspended in the snowy freeze of winter, are the voices of children. All from the third grade (which is when state curriculum mandates units taught on the history of Wisconsin or Madison), the children tell tales of how they too have learned more about this area. Specifically, they explain to us that this land has changed dramatically over the course of geological time.

Like many sciences, geology, it is always assumed, will be updated and changed by new discoveries, new ideas, and theories. Culture, however, must be shaped and changed by radical forces that change it gradually over time, much like rocks formed by water and minerals. Buckingham's film expresses the tension between an academic field and a prevailing mindset.

Growing up in Northern Wisconsin, Nancy Mladenoff was exposed at an early age to the wonders of the natural world. Lake Superior, to this day the cleanest of the Great Lakes, was a constant and dynamic playground for her; frogs, flowers, and trees served as toys and sources for new games and new activities.[17] However, this landscape so rife with possibilities for Mladenoff was also the site of some of the most dangerous iron ore mining in the Midwest. Mladenoff's father, her uncles, and most of her neighbors were also workers in this larger, environmentally damaging industry. From a very young

fig. 11
Nancy Mladenoff, *Vortex*, 2005

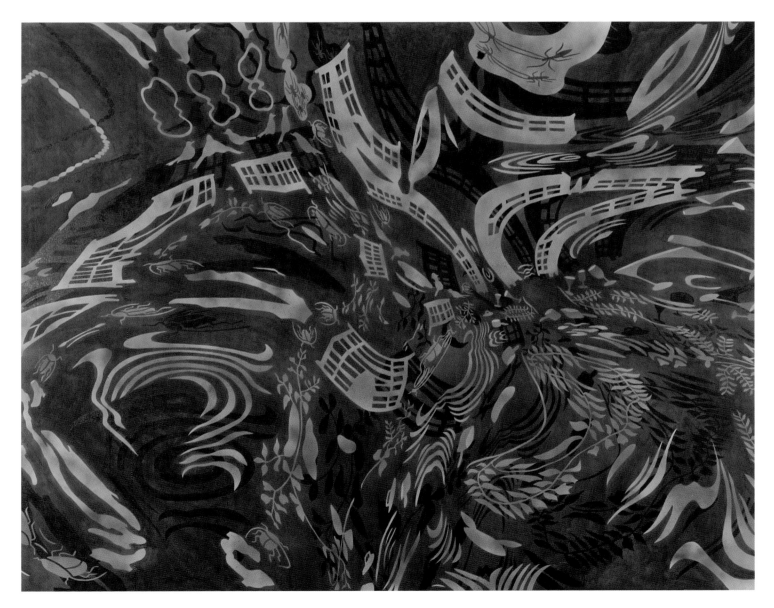

age, the land meant something fragile—beautiful but exploited—to Mladenoff. When Mladenoff came to the University of Wisconsin-Madison in the 1970s as an undergraduate, her interest in the natural world was encouraged and fostered by the resources of the university, known for its research in the natural sciences; she went on to receive her M.F.A. from the Art Institute of Chicago in 1987.

Mladenoff's paintings for *Between the Lakes* return to some of those earlier interests and experiences. The works in the series range from exploring everyday activities, including natural elements, to addressing the constantly changing dynamic between certain species of flora and fauna in our midst. The first painting in the series, called *Vortex*, includes images of wine glasses, sparrows, creeping snowberry, wild indigo, spiders, and cockroaches. (fig. 11) Reading about the history of Madison and thinking about her surroundings, Mladenoff became interested in species that have existed here for thousands of years and in others that were introduced, sometimes to harmful effect. The European sparrow is an example of the latter. First brought to the New World by Europeans who longed for reminders of their former life, this "street bird" (as it came to be known) was introduced to Madison in 1877.[18] Its aggressiveness and penchant for eating voraciously soon forced away many of the other species that live in the city. Mladenoff also discovered that wild indigo, a native plant, is considered poisonous in high doses, but that it was used medicinally by Native Americans for many years. This tug and pull between native and non-native, beneficial and harmful, was just the tension Mladenoff sought for her visually layered paintings.

The third painting in the series, *Undertow*, also delves into themes relating to Madison. (cat. no. 9) For example, it is awash with elongated and graceful images of several docks—structures that Mladenoff saw jutting out from the shore while she was exploring the city, and that we utilize to gaze at and enter into the lakes. Interspersed with the docks in the painting are more examples of advantageous and disadvantageous plants and animals: blue jays make a group appearance in the upper-right corner, and elsewhere in the painting are hummingbirds and, again, the notorious sparrow; three kinds of algae are depicted, namely swift waterpond algae, curly-leaf pondweed, and the blue-green toxic algae. Anyone familiar with the ecology of Madison and the lakes knows that algae is one of the major issues confronting the health of the lakes. While Mladenoff is obviously concerned with this issue, her presentation of it involves layering and juxtaposing the deadly forms (the blue green) with the invasive (the curlyleaf) and the good (the swift). She has always been, as she has stated, "interested in making images." The imagery she catalogues and develops in her paintings is equally a reflection of her aesthetic interests and of the city and its landscape.

Wisconsin artist Truman Lowe has long been influenced by his surroundings. Growing up in the Ho-Chunk community of Black River Falls, Lowe was raised with the undulating rhythms and rewarding landscape of the Black River. Lowe's artwork—utilizing wood, feathers, and reeds—evokes this landscape and its impact on the artist. When Lowe decided to work with ethnobotanist Donna House for *Between the Lakes*, the two of them knew from the beginning that their collaboration would address the loss of life and culture that is central to the history of the region's landscape. Traveling throughout the state, north and south, east and west, the two met with

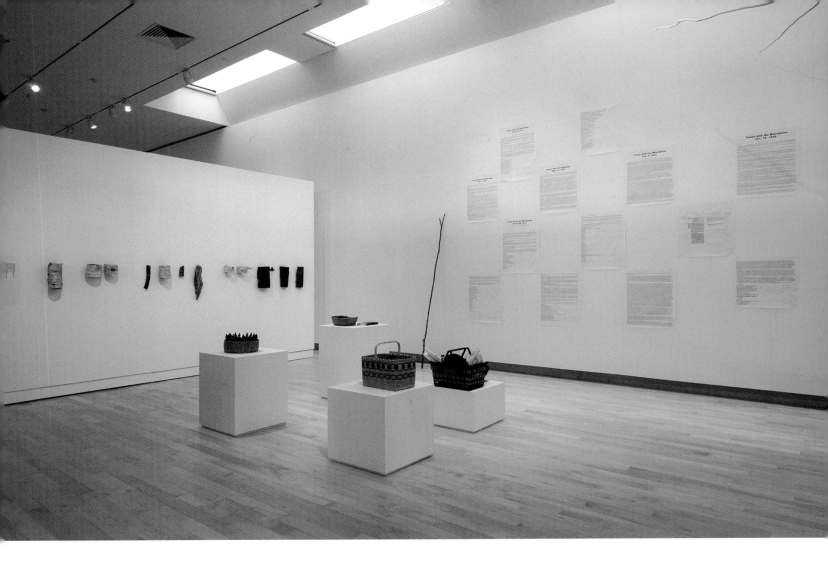

fig. 12
Donna House and Truman Lowe,
Se'e'-t'da-jauh (Since Time), 2006

geologists, landscape architects, and anthropologists to gain a clearer sense of the destruction and exploitation that had occurred here.

In their collaborative work for *Between the Lakes*, called *Se'e'-t'da-jaup* meaning "since time" in Ho-Chunk, a tree stands as the central element. At once referring to the past and stretching toward the future, the tree is a pillar in the gallery representing steadfastness and perseverance. The ghost-like, willowy shapes, affixed to the wall and reminiscent of ribbon appliqué, are based on the handiwork of Lowe's mother. Two of the four baskets, representing the past and the present, demonstrate both Ho-Chunk and Oneida craftsmanship. Each one contains various elements relating to the life of today and to the life that has been lost to us forever: in one of them, corn and medicine bottles show us the past we only barely access, and in another are various examples of metal and plastic objects that structure our lives—from mobile phones to remote controls. (cat. no. 5) Two video projectors installed in the gallery present changing images of native settlements no longer in existence. Mixing the past and present of Wisconsin, the piece expresses a Native perspective reaching out to other stories and culture. The elegiac elements and constructions of the installation make us think about the loss of life and experience that underlies the existence of our own culture. (cat. no. 6)

Taiwanese-born artist Lee Mingwei challenges traditional notions of a work of art. Instead of making objects that occupy a given space in a gallery, Lee's works are collaborations with people, places, and institutions around the world. From his interaction with individuals, certain visual and physical

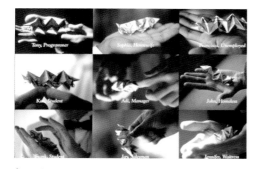

fig. 13
Lee Mingwei, *Money for Art Project*, 1994
(photodocumentation of performance at Cafe
Flor, San Francisco)

fig. 14
Lee Mingwei, *Zhua-Zhou Project*, 2006

remnants develop as metonymic devices for the entire process of the work. For example, while living in San Francisco in the 1990s, Lee devised an idea for a sculpture involving diminutive origami sculptures. Called *Money for Art*, Lee carefully folded ten-dollar bills into different shapes and gave them to various individuals he met in a coffee shop. (fig. 13) A programmer, a housewife, and a homeless person all spoke with Lee in the coffee shop and were asked to steward these precious shapes. Lee tracked their interaction with the objects, and found that some were lost but that John, the homeless man, was able to hold onto to his for many years. Because of Lee's incorporation of process into the work's formation, he was able to uncover our complicated attachment to works of art.

For *Between the Lakes*, Lee quickly knew that he wanted to address the newness of our facility. The first incarnation of the project centered on the notion of giving the new building an American-style baby shower that would christen its public and non-public spaces. Thoughts abounded about cute gifts that might be donated: teddy bears and lovely soft cotton t-shirts. After Lee traveled to Madison to give his lecture and drum up support for his community undertaking, he tweaked the work and decided that it should function more like the ancient Chinese ritual of a *zhua-zhou*.

For a *zhua-zhou*, relatives and friends of a one-year-old baby bring gifts to a party. Today, the objects could be Apple computers, model airplanes, cellular telephones, or paint brushes; once upon a time, they could have been abacuses, writing implements, or calligraphic tools. In fact, for Lee's own *Zhua-*

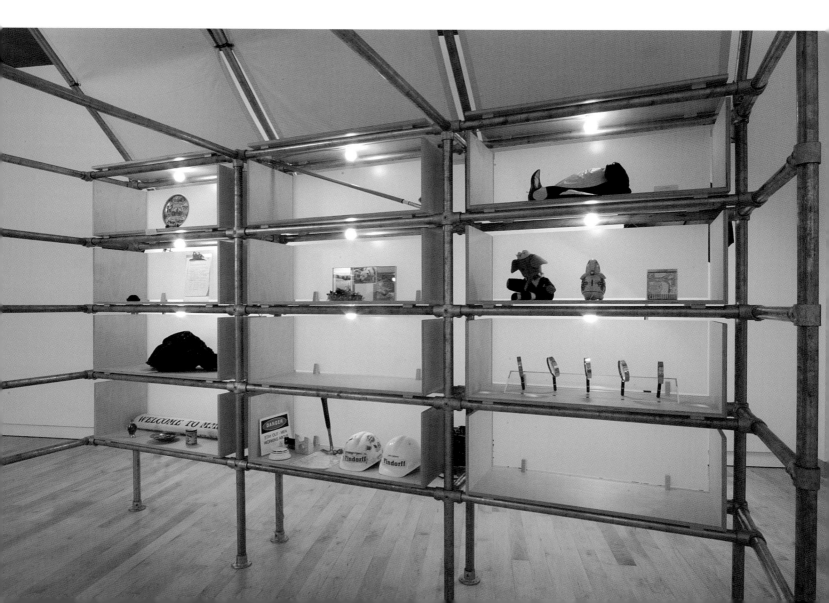

zhou, as he wonderfully recounts, he used the abacus to get his hands on the chicken drumstick. Each item can foretell the successes and professions of the young crawling toddler. The event as a whole begs the question of what role this child will have in our community—what will he or she contribute to the world? The pressure that Chinese parents put on their children is well-known, and this rite of passage is a prime example of such expectation.

Because of the meditation set into motion by Lee's work of art, we can ask, What will change about the Madison Museum of Contemporary Art in this new space? What promises can the Overture Center for the Arts bring to the city of Madison? Rather than simply asking these questions to a few members of the community, Lee encouraged us to ask anyone involved with the project, with the building, with the past and future of the museum, and to get them to think about and then comment on the questions. The numerous responses have been thought-provoking, generous, and loving. (fig. 14)

The first one we received was a heartfelt gift from Claire. A long-time member of the museum, Ms. Mangasarian gave a two-part gift: a drawing by Alice Neel of Joe Wilfer (an employee of the museum starting in the late 1960s who served as director from 1976 until 1980), and a heart pin. According to Mangasarian, a native of Madison, she gave the portrait as one way to show that she hopes we continue to have wonderful directors in the future; and the heart pin shows the broad appeal of the museum and how so many of those people who are involved with us—volunteers, board members, staff members—feel a special affinity for the museum.

Some of the other gifts, a money ball, for example, signify the broad desire for the museum to retain monetary solvency in the future. With a new building and mounting expenses, this will be a challenge, but a welcome one. Other gifts, such as the Genesis batch, commemorating the space shuttle with the same name, or a wine glass filled with wishbones, signify that the museum could be able to reach new heights artistically in a way that we could not before. (cat. nos. 7 and 8) This could mean more exciting exhibitions, more visitors, and most important, more innovation. Gifts from the skilled team of construction workers that have labored over this building reiterate that the Overture Center for the Arts has reached deep into the community of this city. In the end, Lee showed all of us that art might begin with the artist, but it always includes the rest of us.

Madison is not an easy city to define or encapsulate in a single exhibition. The various dramas of its past, from the glacial retreat to the sheer determination of James Doty, give us a rich history that requires constant research and curiosity. The seven artists who have participated in *Between the Lakes* researched different episodes of the past, and each artist created works that delve into the stories and issues of this city. Recurring themes of the beauty of this site, the need to safeguard our environmental wonders, and how our own relationship to the past is a constantly shifting platform emerge as important themes in this exhibition christening the new Madison Museum of Contemporary Art.

1 David Mollenhoff, *Madison: A History of the Formative Years* (Madison: University of Wisconsin Press, 2001), p. 22.

2 Ibid., p. 25.

3 My thanks to Laura Heon, who used this metaphor to describe the artists in *Yankee Remix: Artists Take on New England*, an exhibition that certainly laid important groundwork for *Between the Lakes*. Conversation with the author, November 23, 2001.

4 Armajani, quoted in Nancy Princenthal, "Master Builder," *Art in America*, March 1986, p. 131, from a 1978 interview with Linda Shearer.

5 The excerpt in the installation can be found in Ralph Waldo Emerson, "Art," in *The Essential Writings of Ralph Waldo Emerson*, ed. Brooks Atkinson (New York: Modern Library, 2000), p. 282.

6 See walkerartcenter.org.

7 Robert D. Richardson, Jr., *Emerson: The Mind on Fire* (Berkeley: University of California Press, 1995), p. 3.

8 See the essay "Spiritual Laws," in *Essential Writings of Ralph Waldo Emerson* (see n. 5 above), p. 172.

9 The comparison of this house to the Old Manse is from Kenneth Sacks, email to the author, January 10, 2006. Armajani related the house to Hugo's in a conversation with the author on September 8, 2005.

10 Exile has been a consistent theme in Armajani's works over the years, recurring in the title of several sculptures, although his own relationship to exile is more complicated. For one discussion of this issue, see Calvin Tomkins, "Profiles (Siah Armajani)," in *The New Yorker*, March 19, 1990, pp. 48–72.

11 Armajani, email to the author, February 22, 2006.

12 For a recent example of this, see Michael Kimmelman's review of Jon Kessler's installation at the P.S.1 Contemporary Art Center in the *New York Times*, November 11, 2005, sec. E, p. 2.

13 Although Armajani has long cited Emerson as a very influential figure in his life and his work, his overt references to the man or his teachings are rare. He incorporated a quote from Emerson in his piece for the Hudson River Museum in 1981, and another quote from Emerson in the installation of his retrospective at the Museo Nacional Centro Reina Sofía in Madrid in 2000.

14 Soth, email to the author, February 24, 2006.

15 *Life Magazine*, Sept. 6, 1948.

16 See "Ice Age Clues Unearthed from Construction Hole," www.uwex.edu/wgnhs/

17 One of Mladenoff's paintings, *Who Will Run the Frog Hospital?*, was inspired by her experience working with a friend to save frogs injured by malevolent boys wielding bee-bee guns. Lorrie Moore used the title of the painting for her novel about an unhappily married woman named Benoite-Marie Carr and that character's friendship with another girl when they were teenagers.

18 Mollenhoff, *Madison: A History* (see n. 1 above), p. 233.

Katy Siegel

For my father, Frank Siegel, born in New York,
a devoted Madisonian for over forty years,
and a wonderful painter.

On Wisconsin

"As for Madison's wants, we must not be overly discouraged by the recent recreation survey in which an interest in ice-skating rinks placed well above requests for an art gallery."

—Janet S. Ela, 1951[1]

Growing up in Madison, I never thought about art. That doesn't mean it wasn't part of my life; in fact, I guess our house was full of it. My father, my grandfather, my great-aunt, my grandmother's best friend all made art. They painted dogwood branches and seascapes, nude women, geometric compositions, and city scenes in watercolor, oil, and acrylic. None of them were "great" artists, judged against Picasso, Mondrian, Manet. Nor were any of them particularly bohemian: middle-class Jews, working-class Southerners, perhaps personally eccentric to some degree, they nonetheless maintained steady jobs and homes and families. They all had the idea, though, that it was interesting to make art. Making things was part of life, of work as well as recreation: the Southern side of the family made furniture and quilts, and the Jewish, Eastern side made office machines and biochemical experiments.

As a child, the only art museum I remember going to was the Elvehjem; I have no memory of the print collection or particular traveling shows, but only of the bright, modern works on the top floor: Plexiglas sculptures in rainbow colors (Judy Chicago? John McCracken?), and psychedelic posters I now assume were by Peter Max. I liked this stuff, probably because it looked like my toys and books, but bigger and even brighter. But the museums I went to were almost all natural-history museums. A trip to Chicago meant the great Museum of Science and Industry, where the highlight was always a ride through the simulated coal mine, followed by a trip to the Shedd Aquarium. A really big trip, to London when I was eleven, meant we got to see the waxworks at Mme. Tussaud's, the crumbly bits and armor at the British Museum.

Often, however, while my dad and my brother and I were admiring the fish and the dinosaurs, my mother went off by herself to the Art Institute or another big art museum. What inspired her to do this? I have no idea. She

was from a poor, rural family, where art was entirely homemade, and no one ever set foot in a museum or took a class about art. Maybe she learned it was something you were supposed to do from the other faculty wives. Maybe the sense that there was something finer that led her to bury herself in books led her to art as well. In any case, eventually she took an art-history class at the university, and loved it. When I went off to college, she urged me to take a class, too.

Not New York

"Madison was at least fortunate in finding leadership for the art-appreciation gropings it was undergoing, for the University was attracting numbers of men and women who had lived in eastern cities with wider art horizons than our own."

—Janet S. Ela[2]

The art I saw in my college art-history survey was totally different from anything that I had grown up with. For the first time, I was aware of "great art," objects made with tremendous skill, thought, and social resources by trained artists: the tomb of the Medici, the Parthenon, improbably monumental and ambitious; paintings by Velázquez, Manet, and Watteau, fantastically beautiful. And the art of the twentieth century, though rarely awe-inspiring or beautiful, was so *serious*. It *meant* things—expressed deep emotion, furthered the cause of painting, challenged society, questioned all the art that had gone before it.

The twentieth century art also appealed in its weirdness; as a typical outcast teenager, I had spent hours holed up in my bedroom reading Oscar Wilde and Arthur Rimbaud, and any other books that sounded like they were written by people who were not popular in high school. The art in my college art-history survey matched my reading list: it was full of naked people, gay people, cut-up photos and collages, stuffed goats and dripped paint, angry slogans, and personal and political resentments and sentiment. As much as this new world thrilled me, I noticed that the other students in the class accepted it, but didn't seem particularly galvanized by it. They knew about this stuff; it was already part of their world.

This was the other part of my college education, one that went hand in hand with the introduction to "real" art: all the people I met who were from New York, including my roommate and most of my friends. The school had a large population from New York City and its environs, and they were concentrated in art-history classes. I had never been to New York; my Southern mother had vowed never to go there, and saw it as the epitome of all things dangerous and foolish. But I admired the sophistication of these other students, the girls especially, who dressed so well, knew so much already (about art, school, and other subjects), and seemed to roll along even as I struggled with schoolwork and social life. Everyone assumed I came from "the country" (surrounded by cows), or at least "the suburbs" as opposed to "the City"—a term whose uppercaseness confused me. ("Which city?" Apparently there was only one).

The awareness of provincialism had been below the surface of my consciousness growing up, but it is very much part of Madison's self-image

and history, and rears its head from time to time, with increasing frequency today, I think, particularly in cultural matters. The only time I remember thinking about the cultural capital of New York while growing up was in 1979, when Pail and Shovel student-body president Leon Varjian (himself a New Jerseyite) engineered the apparent submersion of the Statue of Liberty in Lake Mendota. Varjian and co-conspirator Jim Mellon had promised, if elected, to buy the landmark from New York and bring it to Madison; they claimed that the statue had been tragically and inadvertently dropped into the lake while being flown in by helicopter. And so, stepping out in back of the Student Union, you could see the head and torch of Lady Liberty towering forty feet above the ice. (fig. 15)

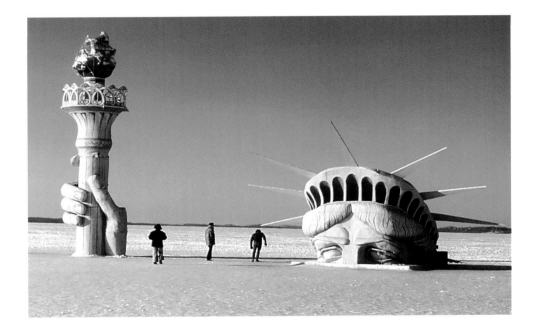

fig. 15
Michael Kienitz, *Lady Liberty at High Tide*, 1980. Courtesy the artist

It was, of course, a very funny prank, on sheerly visual grounds. The funniness also rested on a certain tension between New York and the cowtown provinces, the idea of wresting prestige and culture and centrality from one to the other—and ultimately failing to do even that. There was a darker undertone as well: the image almost exactly recalled the one at the end of the 1967 movie *Planet of the Apes*, when Charlton Heston sees a semi-buried Statue of Liberty and realizes that the primitive wasteland he has been flailing around in is actually Earth, and that New York has devolved and is being run by monkeys. (fig. 16) Were they saying that Madison was primitive in some way, as well as provincial? These certainly were the "boring" years of Madison, conservative political and cultural times (in keeping with the national malaise) sandwiched between its history of progressive politics and student activism on the one hand, and its future of sophisticated urban development on the other.

Tensions between Madison's midwesternness and "outside" elements from the East Coast are perhaps even more pronounced today. A standard part of freshman orientation here at the university seems to be a discussion of stereotypes of coastal culture vs. midwestern culture.[3] Although a little more than half the students at the Madison campus are from Wisconsin,

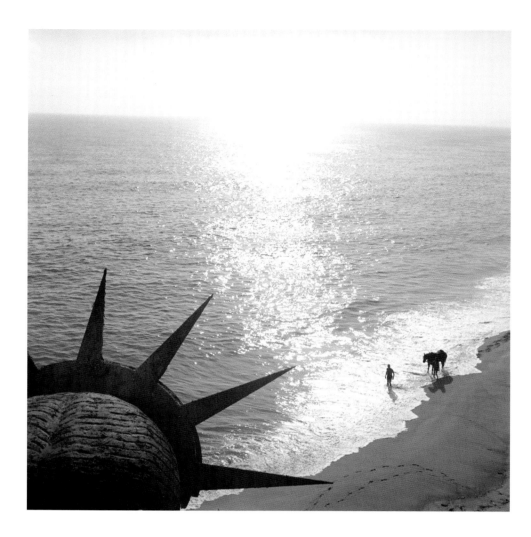

the next biggest contingent—about one-third—come from New York, New Jersey, California, and Illinois (meaning mostly Chicago and its suburbs). Called "coasties," these students tend to be urban, affluent, and ironic in their take on midwestern mores; as described in local papers, the conflict between earnest midwesterners and jaded fashion plates from New York is comic relief in the larger context of the religious, ethnic, and tribal strife that rocks the planet. The conflict does have a more serious aspect. Class is a part of it; as one New Jerseyite says, "They look down on us just because our parents have a little bit more money, because we talk about where our fathers work. They want to feel superior to us because they think we think we're superior to them. Then we're forced to."[4] The freshman's sense of irony is, perhaps, underdeveloped, but the point is that the geographic divide is also monetary. Distinctions between the two groups of students revolve around living in the standard U.W. dorms and paying in-state tuition vs. luxurious private dorms and out-of-state tuition, and also around cultural differences (for example, wearing flannel shirts vs. Ugg boots and big sunglasses) and, more fundamentally, character: authentic vs. cosmopolitan.

The conflict between the provincial, local, and conservative, and the sophisticated, urban, and avant has underpinned the long history of the Madison Art Association since its 1901 inception. As in the epigraph to this section suggests, it was often people who had spent time in New York and other eastern cities who led the "art appreciation gropings" of the local community. These

34

cultural leaders, along with small numbers of other middle- and upper-class citizens, sought to bring sophisticated art to Madison of the kind that they themselves had seen in Europe and in the museums of major American cities.

When it began, the Madison Art Association was distinctly not interested in local art; although the exhibitions were put on for the education and edification of the young and the unwashed public, those goals seem to have been little pursued in actuality, or were at least secondary to the presumably edifying exhibition program itself, which mostly featured contemporary American art, in keeping with mainstream art trends. As for exhibiting local artists, memos from the directors often admonished along the lines "that only in case of celebrated artists can the Association take charge of personal exhibits."[5] Meaning that their venue was intended for artists of national and historical importance, rather than local artists, and in fact, no local artists were given shows in the early years of the institution.

During the 1920s, the Association began to recognize local artists, first with shows of University art students, and then, in 1925, with the first of what were to become annual juried exhibitions of Madison Artists.[6] The lecture program was divided between national and international figures such as Alexander Archipenko, Walter Gropius, and Le Corbusier and well-known Regionalist artists including Thomas Hart Benton, Grant Wood, and John Steuart Curry. The latter were especially appealing to a public wary of European and East Coast artists, who were perceived as weird or elitist. Discussing Curry's time in Madison as an artist-in-residence at the University, local historian Janet Ela observed, amusingly:

> Mr. Curry's special contribution to our actual program came later, in the school Art Show, but perhaps our best asset of all was having him here in Madison where we could get to know him. I suspect that a number of Madison men who were poor prospects for lecture and gallery going were won over to art's possibilities by first hand acquaintance with this unassuming, extremely manly painter.[7]

Manly, folksy art celebrating farmers and "regular people" is not of course, the only kind of artistic production associated with regional identity. The other key element in the history of Madison's local arts programming has been craft. Like local or regional art, craft is often posed in contrast with high modern art. The primary contrast is that craft objects have the potential to be useful, whereas art, by definition, is only for aesthetic, spiritual, or intellectual edification. Craft is also the province of amateurs and handworkers in an art world driven by professionalism and concepts, even when craft aspires to the condition of art. This tension is evident in the varying opinions on the work of glass artist Dale Chihuly, for example, which is held in higher esteem by those interested in craft (as well as by the general public) than by art critics. Wisconsin has a particularly rich tradition in glass, handmade paper, bookmaking, and textiles, both at the university and in the larger community, and the Madison Art Association and, later, the Madison Art Center traditionally stressed these areas in exhibitions. (fig. 17) The craft event in Madison with the highest visibility is the Art Fair on the Square, held since the late 1950s, and sponsored by the Madison Art Center. We went to it every year when I was growing up, and I loved it, despite the crowds—the objects were cute,

fig. 17
Art Fair on the Square, organized by the Madison Museum of Contemporary Art, 2003

clever, and well-made, and sometimes our parents would buy a small animal figure for us, or a piece of pottery for themselves.

Of course, learning to prefer "high art" to craft was part of my education in college, where I was a local person learning to be a coastal person of sophisticated taste. This new wisdom went along with the revelation that I shouldn't be sleeping on 50/50 poly/cotton sheets or wearing pantyhose (or anything with synthetic fibers, for that matter). Graduate school in art history intensified the process. When I began, I dressed in the wild, fun clothing I wore in college—used golf dresses and leopard-print miniskirts—and the old house I rented was filled with plastic flowers. By the time I left, I was decked out in clean neutral colors and ready for my minimalist apartment and my first full-time teaching job. This was, in part, simply the story of growing up and being indoctrinated into the professional world. But the transformation also paralleled the gradual shift in my intellectual self-image, from one in which I was having fun, trying out creative ways of thinking and writing, to one in which I was engaged in something serious and important on a historical and international playing field. It turns out that what I thought was a very personal story of new experiences and changing tastes was, after all, typical and social.

A Tale of Two Soglins

"You'll enjoy this one: Just because someone else makes a profit doesn't mean the rest of us lose."
—Mayor Paul Soglin to the Madison Rotary Club, 1997[8]

I finally got to New York a few years after graduate school. I went for a year on a fellowship from my university to do historical research on Jackson Pollock, Willem de Kooning, and the other New York School artists of the 1940s and '50s, ; I ended up becoming immersed in contemporary art, writing about it for *Artforum*, the most cutting-edge and highbrow of the mainstream art magazines. Once again, the experience was thrilling: I was seeing "real" contemporary art for the first time, and listening to artists talk about their work, and the level of creativity, thought, and skill introduced ideas and experiences that I had never imagined. The intellectual questions were vital and engaging, and when I began to write art criticism, my editors were always asking me, "What's at stake?" They urged me to up the ante, to give the reader a sense of the vital issues pressing on the artists, and the risks they were taking in their position.

At the same time that I was looking at the art, interviewing the artists, and writing about them, I was also beginning to be invited to the social events that accompanied the art-making and exhibiting, a side of things that certainly was never discussed in my art-history classes, and rarely, if ever, in the art criticism I read and admired. The openings and parties were filled with artists and curators, with wealthy people, with the fascinatingly rebellious but beautifully dressed. It was exciting, of course—I had been to about three parties total in college, and here I was at really glamorous parties in New York—but it also felt strange. Both the pressing social critiques that filled art (according to both artists and critics) and the deeply felt private experiences

that the art communicated were in sharp contrast to the actual life of much of the art world, where the talk about art tended more toward business chit-chat, and the events were in some ways indistinguishable from any fancy society event.

My naïveté was a little ridiculous, and it rendered the contrast between art's ideals and realities a too starkly. Contemporary art is not a fraud, not "just" a luxury good or social merit badge. And yet my experience does speak to some of the reasons contemporary art has become such an essential component not just of life in New York, but of the revival of the American city. Contemporary art in the most current international mode—as opposed to regional art or craft—has always represented culture and cosmopolitan values, as evident in the early aspirations of the Madison Art Association. During the past ten years or so, it has more and more clearly come to symbolize, and even generate, a city's identity as modern, up-to-date, part of the fast-paced international world of the moneyed and cutting-edge elite. So in New York, museums have increasingly emphasized collecting and exhibiting contemporary art, even institutions that did not do so before, such the Metropolitan Museum of Art and the Museum of Modern Art. And many museums across the country have either opened or undertaken ambitious expansion plans, financed mostly by wealthy private donors, businesspeople in the community.

Part of the expansion and modernization of these local museums often includes a sharpened focus on contemporary art, and, as a result, many of them have adopted new names. Most people accepted the 2003 renaming of the Madison Art Center—to the Madison Museum of Contemporary Art—as a non-issue, or even a welcome move toward a more sophisticated mission for the museum, but some local commentators were alarmed by what they considered a turn from community concerns and local artists. As one Madison columnist (complaining primarily about the recent name change of the university's art museum), wrote, "There was something endearing, and very

fig. 18
Members of the Madison City Council take the oath of office, 1973. Individuals include Paul Soglin and Eugene Parks.

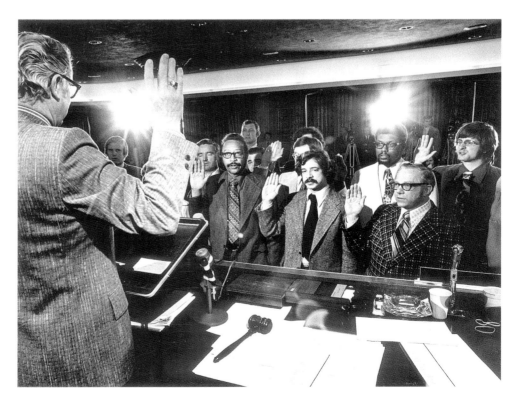

Madison, about the name the 'Madison Art Center.' It suggested a certain populism, not some puffed up and pretentious me-too elitism."[9] A Milwaukee reporter made similar complaints about his local museum's transformation from the Milwaukee Art Center into the Milwaukee Art Museum (M.A.M.), which has attracted attention for both the ambition of its architecture and its contemporary-art program. The Milwaukee project was specifically intended to show that the city—one of the famously and most intractably blue-collar cities left in the U.S., as immortalized in the television series "Laverne and Shirley"—had entered a new era of sophisticated, moneyed modernity. The Milwaukee columnist compared M.A.M.'s new image to Madison's perceived abandonment of "amateur fripperies: basket weaving, pot throwing, Sunday painting and the like. Hence, the new name—and the initials, MOCA. The Madison Art Center was unique, endearing and, in my view, irreplaceable, whereas MOCA is rapidly becoming a generic term."[10]

Such comments reduce a complex development to a simple contrast between an idealized, imaginary past and an equally imaginary present dominated by cultural carpetbaggers. Anxiety about a name change is actually anxiety about changes in the city itself. Madison *has* changed, despite the coastie/midwestern tension at the University. A city that was once liberal now seems more *neo*-liberal. Now when I come back to visit my family, there are wine bars and fancy restaurants and Whole Foods supermarkets where once there were beer bars and fish fries and food co-ops of the more fibrous and less gourmet variety. Some aspects of those cultures survive, but now they exist alongside the kind of businesses that, if not precisely the same as those in New York, are the same *kind* as those in New York or Chicago. All this new business is predicated on the development and renewal of downtown Madison, the return from the suburbs of wealthy, mostly white people that characterizes urban culture across the U.S. today. When I was young, the Square only came alive on Saturdays for the farmer's market; the stores had largely vanished, and it was quite desolate, just as State Street became seedier past the Civic Center, further away from the university. Now the Square is filling up with luxury condominiums at prices that again are not quite on the level of New York, but are high enough to shock me as a native Madisonian,

fig. 19
Paul Soglin, Bert Zipperer, Will Sandstrom, Davy Mayer, and David Cieslewicz addressing the Madison Rotary Club, 2003.

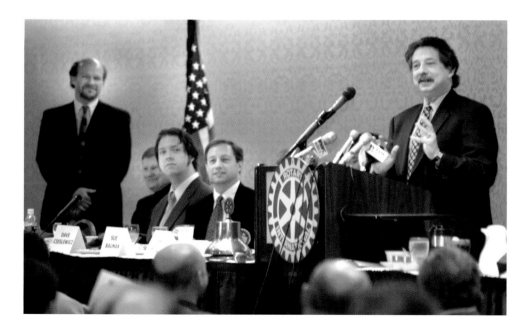

and you can venture out of your penthouse week-round in successful search of croissants and caipirinhas.

There is no better nor more ironic symbol of the changing nature of Madison than the two mayoral runs of Paul Soglin. (figs. 18 and 19) The contrast is sharp, and it's almost too easy to wring paradigmatic significance from it. His first term began in 1973, when Soglin followed runs as a student radical and a city councilman with election to the mayor's office at the age of twenty-seven. He won national attention not only for his youth but for his declared position as a socialist, and for meeting with Fidel Castro (to whom he gave a baseball signed by Hank Aaron). In his six years in office, he worked for public transportation, bicycle routes, housing for the elderly, and hiring women firefighters, as well as founding the Madison Civic Center on State Street (eventual home of the Madison Art Center). Soglin then spent ten years in private law practice, returning as mayor when he ran again and was reelected in 1989. This time around, he had different goals, the primary and most controversial being the building of the Madison Convention Center. Despite its architectural pedigree of a Frank Lloyd Wright design (which had never been built), the Convention Center drew enormous criticism and opposition from many different segments of the community, who saw it as a pro-business boondoggle that sought to line the pocket of developers, founded on the deluded idea that Madison was a big city that could attract business tourism with the Wright building. Soglin prevailed, bolstered by his new business bedfellows, and the center opened in 1997. The contrast between a "civic" center for the people, built in the 1970s, and one for business, built in the '90s, was marked, and remarked upon.

And yet, the new building is beautiful, the design genuinely distinguished. The old Civic Center, which I remember fondly, was a confusing architectural hodgepodge, filled with awkward angles and dead ends. Similarly, the new Overture Center is one of the most beautiful concert halls I have ever been to anywhere. It puts Lincoln Center and other famous venues to shame. Perhaps this architectural excellence outweighs the implied shift from "Civic Center" to "Overture Center," a name chosen by the donor, who modestly did not want it named after himself, despite his extremely generous contribution.

You *Can* Go Home Again

"So, how's ol' Madison, Wisconsin? Is that Paul Soglin still the mayor? And is Rennebohm's expanding? Is the Club de Wash still there? I used to sit out on the Terrace, and watch my grade point disappear. For the life of me, I don't know how I wound up here."

—Peter and Lou Berryman

It's exciting to come back home to visit and see all the changes; I like to eat in the new restaurants with my family, and it's both strange and wonderful that I can see art exhibitions—Rodney Graham, Robert Frank—here that could be just as easily imagined in New York (or London or Berlin). But sometimes it makes me a little sad, too. Maybe now that I live in New York and am positively overrun by big-time professional culture, I wish my provincial pocket would remain quaint, with site-specific culture such as cows around the

concourse and wildlife watercolors, much as the twentieth-century Spanish tourist visiting Peru wanted to see paintings of peasants in the marketplace, not neo-concrete abstraction.

But after all, if I want midwestern culture, I can get it in New York. Brooklyn, where I live, has Wisconsin-style bars with names such as Great Lakes and Floyd's, complete with wood paneling and animal heads (although reasonably-priced beer doesn't seem to have caught on), that are totally alien to the borough's own native style of boîte, the Italian "social club." Manhattan is home to many woodsy, lodge-like restaurants, and stores where I can get fabulous cheese from small Wisconsin producers whose products I have never seen in Madison. Recently, the art galleries too have been full of art suited to urban dwellers with a yen for the woods, abounding with landscape painting, Tudor-ish installations, and inordinate numbers of frolicking deer. It's not just the Midwest that's in fashion, of course: the city is also currently dotted with New England seafood shacks, Southern barbecue spots, and other regional down-homeries. Similarly, beyond moment-to-moment artistic trends, there is the enduring phenomenon of do-it-yourself art—the macramé of Jim Drain, Sarah Sze's Home Depot sublime—in the most professional and highbrow of galleries.[11] This art is underpinned by a more general cultural obsession with knitting, *ReadyMade* magazine, and other kinds of D.I.Y. arts and crafts, a strange cultural skein amidst the fabric of luxury and professionalism that borders on the obscene in New York today.

Bizarrely but inevitably, the ironic and distanced celebration of the regional has reached Madison itself—the ultimate sign of its sophistication. The nouvelle cuisine of L'Étoile (itself part of an earlier local-foods movement catering to elite and often out-of-town chowhounds) and the various fancy international restaurants dotting downtown have recently been joined by a restaurant "inspired by the traditions of Wisconsin taverns and supper clubs." (Fish fries? Cheese curds? Strangely sweet brandy drinks?) Just as the desire for eccentric, imperfect handmade art (and craft) is a symptom of a mass-produced world, the sudden emphasis on the regional—in food, music, and other forms of culture—is a symptom of its disappearance in a global world.

There is no real solution to the tension between the center and the province, the global and the local. Strategies of emulating more central modes of culture and of enshrining the regional are equally fraught, and it's hard to come up with alternatives. One is the interest in site-specific art, wherein national or international mainstream artists come to a locality and, after spending some time there, produce works of art specifically about that place. In the worst case, the result is a hit-and-run critique of what's wrong with the local venue, with little insight or self-reflection on the part of the artist. In the best case, those artists bring fresh insights into and even appreciation of the place, something that natives might never notice, even inspiring a sense of validation and recognition. I love Alec Soth's photographs of the South (and more recently of Niagara Falls), and it is a particular thrill to see him turn his camera to Lothlorien co-op, where I lived for a short time when I was eighteen. Soth's choice of subject hints that the older, liberal Madison (Lothlorien was known for vegetarian cooking, rigorously collective decision-making, and optional clothing) persists, that change never happens decisively, conclusively, all at once, irrevocably. Nostalgia and irony are not the only ways in which the past is embodied and moves into the present.

In the song quoted above, the Berrymans (world-class lyricists and musicians specializing in songs of Wisconsin) give voice to the worldwide diaspora of people who came from out of state to go to school in Madison, then left again, and remember it with great nostalgia. For them, remembering Madison is bound up with remembering their own youth: "I don't know how I wound up here" is a plaint about time and freedom lost, as well as geographical displacement. "Here" could mean New York or Philadelphia or Orlando; it could equally mean a brokerage firm or a house in a gated community or a three-piece suit. The Berrymans' funny and sad refrain might work equally well then, not only for former coasties returned to their natural habitat, but for displaced Madisonians, or even people who still live in Madison and miss a previous incarnation of the city—before Rennebohm's drugstore turned into Walgreen's and before the live music dive bar the Club de Wash burned down.[12] The plaint is really for anyone who misses the place and time before they unlearned what was possible, before they entered the big world, with all its disciplines and pleasures.

Like Soth, the Berrymans remind us that what is authentic, what is regional, is not necessarily stereotypical—it doesn't have to be the flag-waving prairie images of American Scene painters such as Curry or Thomas Hart Benton or Grant Wood any more than it has to mean a tavern filled with hunting trophies. It means different things to different people of different generations at different moments. And so "outside agitators" such as (the young) Paul Soglin or smart-ass Leon Varjian represent the "real" Madison for many people, just as the weirdo hotspots Loth Lorien or the Club de Wash do, or did. The authentic so often means what you yourself experienced at a particular formative moment, and so it is unfixed, always changing.

I want to end with another quote, this one from the brilliant British art critic Lawrence Alloway. Alloway was famous for being able to "see" and appreciate British and American Pop art at a time when it baffled many other critics. What gave him this insight? Was it because he was the most current or sophisticated interpreter of new artistic or academic theories? Not exactly. Here, Alloway describes his background:

> In England I grew up without giving up any of my earlier phases of culture. As I didn't go to university or anything like that there was no pressure to give up my juvenile culture of science fiction and western movies . . . The traditional process of education involves sacrificing one's sort of high school culture, as you move into serious things. I never really wanted to narrow culture down to a few precious things. I always kept it rather wide open.[13]

He understood new art forms because he was open to them, because he came to them with all of himself, not just the acceptable, sophisticated older self that lived in London. Alloway points out what is valuable about the broader definition of culture familiar to the young, the amateur, the provincial. I like to think that my early experiences of the art in my house, made by friends and family, as well as the time spent in the aquarium, in the science museum, and all the rest of it are just as valuable as my later education in art history and my experiences of contemporary art made by professional artists, just as I hope that the earlier moments in the life of Madison are still present in its most recent incarnation—and in its new museum.

1 Janet Ela, *Madison Art Association: 1901–1951* (Madison, Wisc.: Madison Art Association, 1951), p. 101.

2 Ibid., p. 11.

3 As per Wren Singer, director of orientation and new student programs at the University of Wisconsin-Madison, in Megan Twohey, "The Great 'Coastie' Divide," *Milwaukee Journal Sentinel* (November 15, 2005), pp. 1A, 8A.

4 Randy Frankfurter, quoted in ibid.

5 Quoted in Ela, *Madison Art Association* (see n. 1 above), p. 32.

6 Ibid., p. 63.

7 Ibid., p. 81.

8 Soglin, quoted in Steven Walters, "From Radicalism to Capitalism: Soglin Is Converted," *Milwaukee Journal Sentinel*, April 13, 1997, p. 1A.

9 Jacob Stockinger, "Name Change Dishonors Elvehjem," *Capital Times*, May 12, 2005, p. 1C. The debate about the name change at the Madison Art Center also invokes the controversy over the recent name change of the U.W. Madison's art museum from the Elvehjem Museum of Art to the Chazen Museum of Art—a shift from a local, Norwegian name to that of a Jewish couple, Simone and Jerome A. Chazen, U.W. alumni who live in New York and donated funds for the museum's expansion. There is an undercurrent of ethnicity to many of these discussions, along with class.

10 James Auer, "Museum Identities Lost in Renaming," *Milwaukee Journal Sentinel*, August 25, 2005, p. 2E.

11 For an extended discussion of this phenomenon, see my essay "Do It Yourself!," in *The Americans: New Art,* exh. cat. (London: Booth Clibourne in association with the Barbican Gallery, 2001), pp. 284–93.

12 Of course, that place and time would be different for everyone: the building that housed the *original* Rennebohm's (dating to 1925) on University Avenue is currently the subject of a fight between the university and those who wish it to be granted landmark status.

13 Lawrence Alloway, in "L.A. in N.Y.C.," *Art-Rite* no. 1 (1973), p. 8

Works in the Exhibition

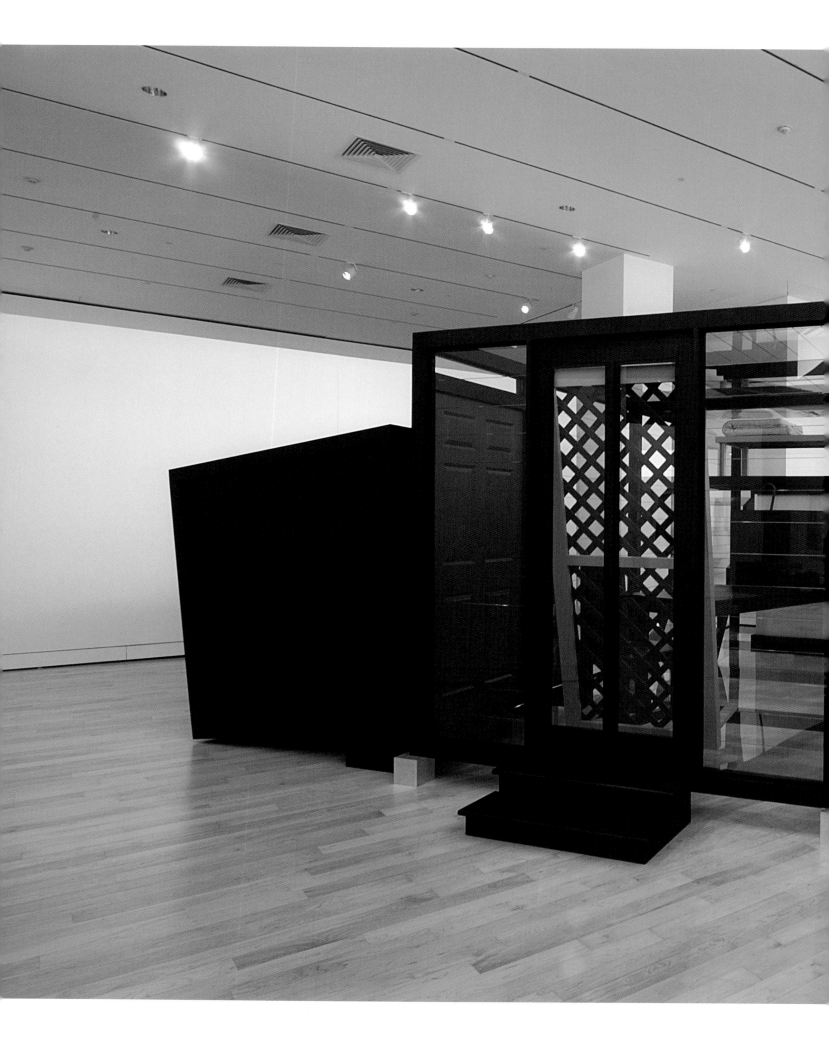

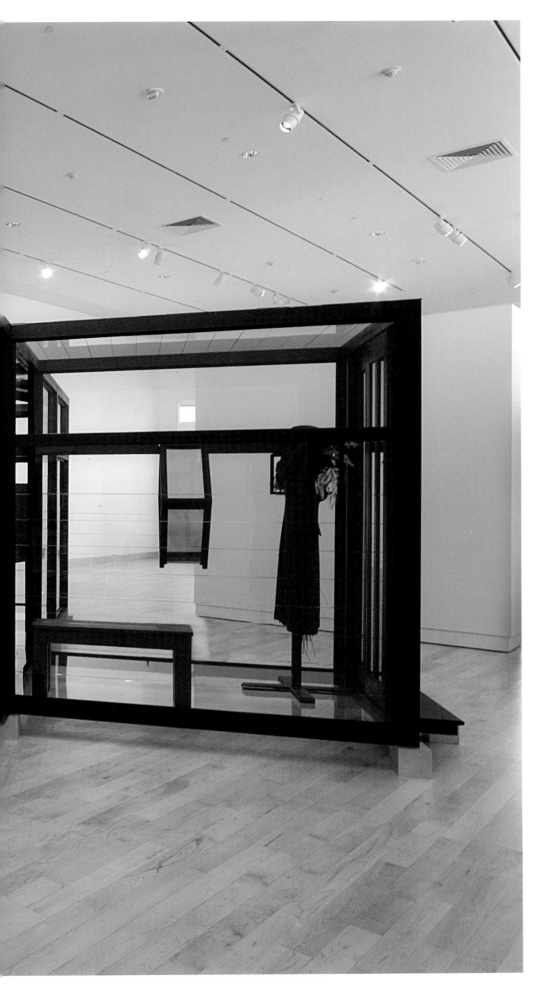

cat. no. 1

Siah Armajani
Emerson's Parlor, 2006
Laminated wood, glass, plywood, metal bed frames, mattress and pillow, white and black paint, wool, straw, black felt curtain, diamond-shaped mirror, coat, and hat
22 x 20 x 10 ft.
Courtesy the artist and Senior & Shopmaker Gallery, New York

cat. no. 2

Siah Armajani
Emerson's Parlor, 2006
(detail)
22 x 20 x 10 ft.
Courtesy the artist and Senior &
Shopmaker Gallery, New York

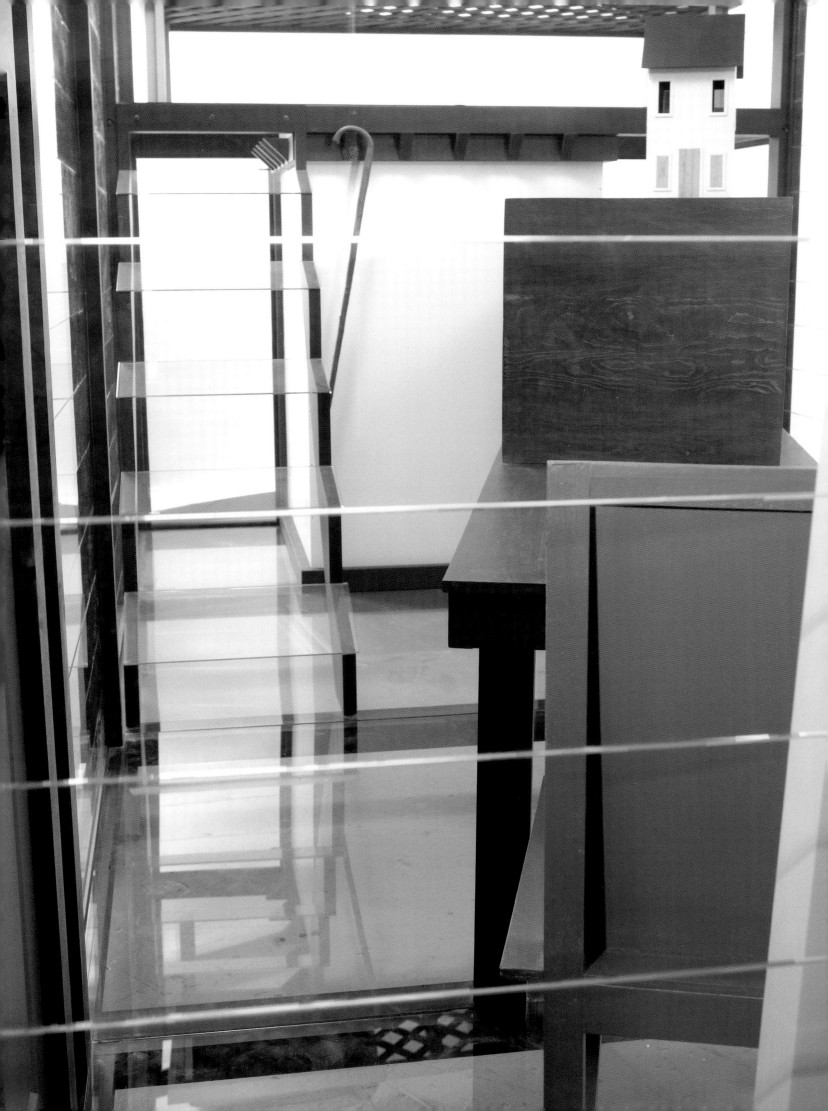

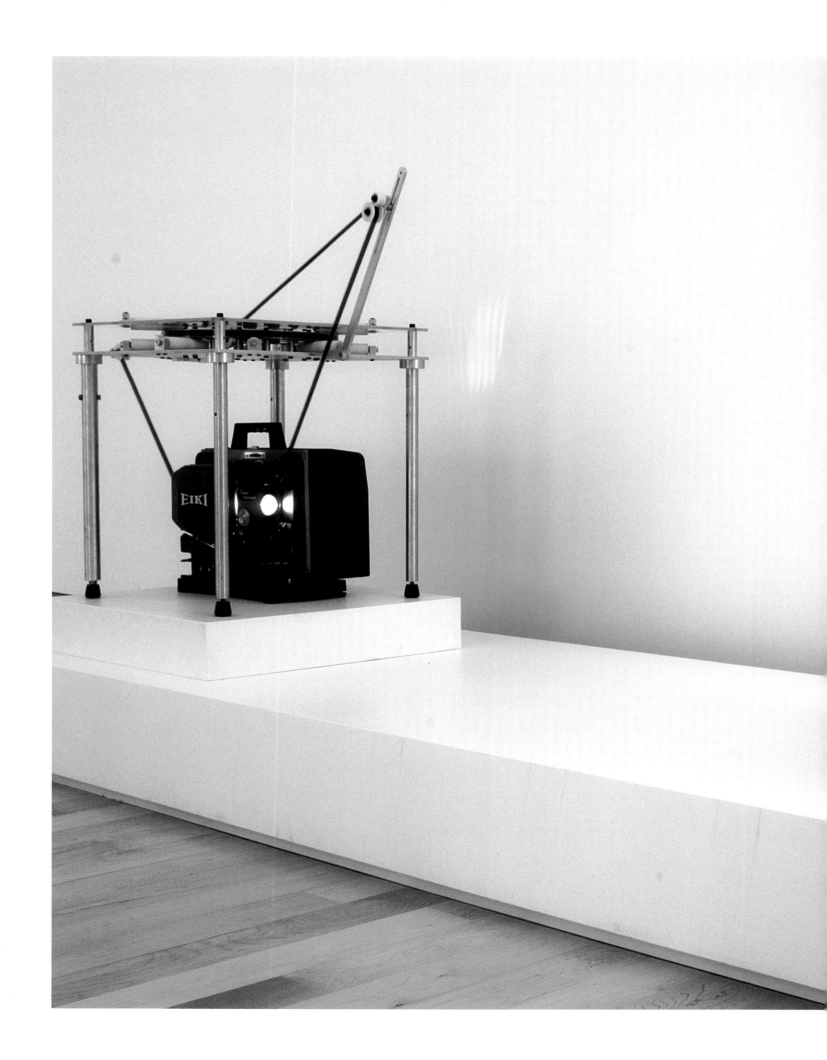

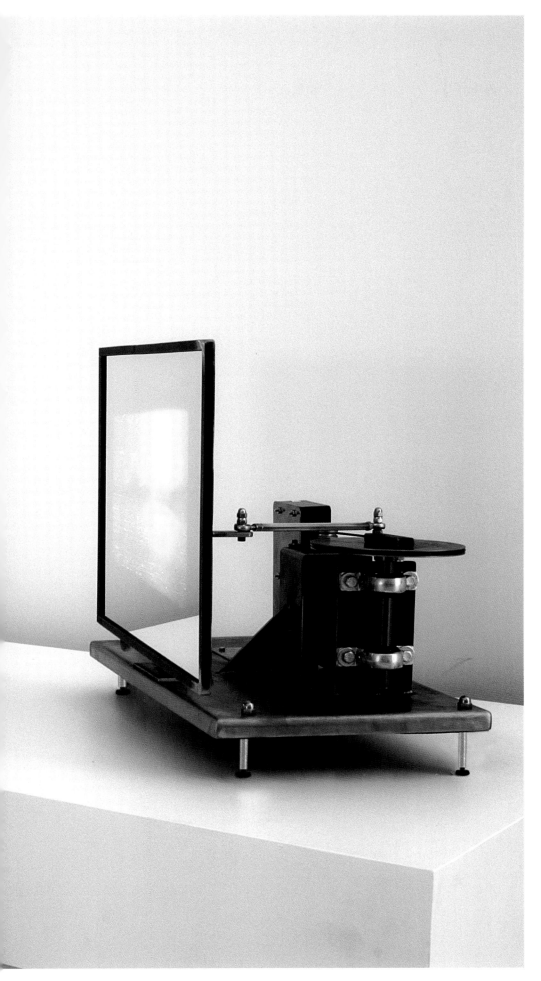

cat. no. 3

Matthew Buckingham
Behind the Terminal Moraine, 2006
16mm film projection with
oscillating mirror
Dimensions variable
Courtesy the artist and Murray Guy
Gallery, New York

Matthew Buckingham
Behind the Terminal Moraine, 2006
16mm film projection with
oscillating mirror
Dimensions variable
Courtesy the artist and Murray Guy
Gallery, New York

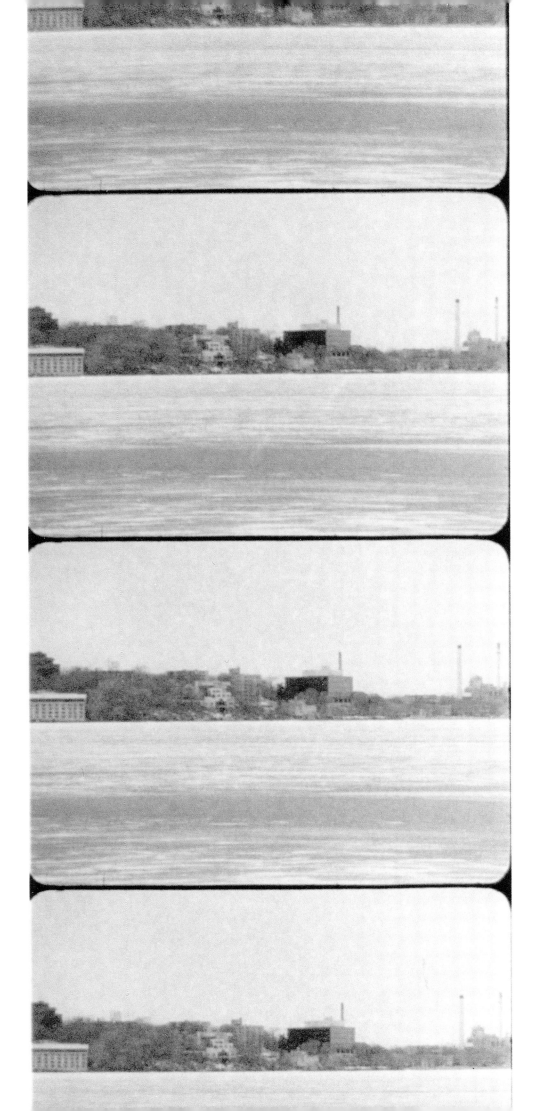

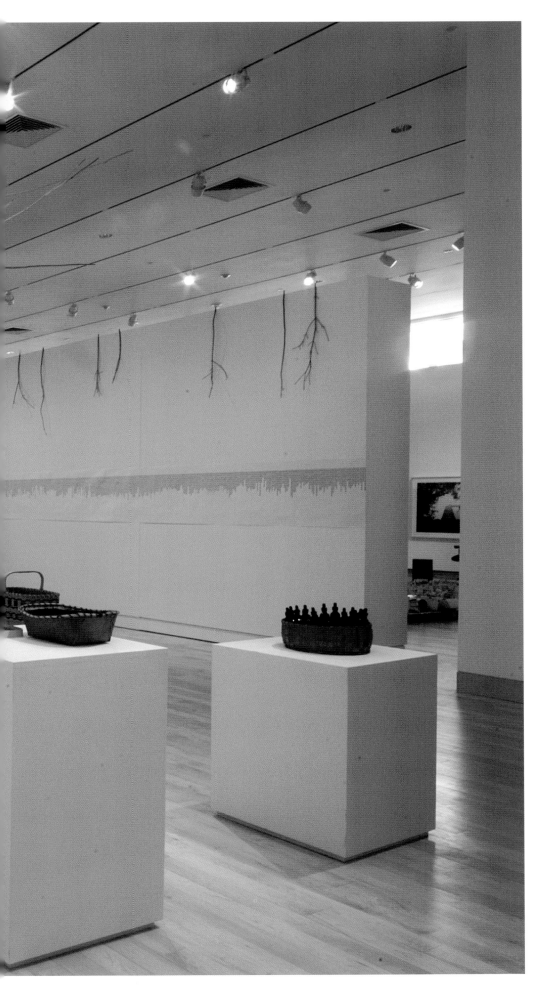

cat. no. 5

Donna House and Truman Lowe
Se'e'-t'da-jauh (Since Time), 2006
Douglas fir plywood; bark of birch, maple,
and white oak; branches of dogwood
and willow; wild rice, white corn, yellow
corn, blue corn, dried cranberries, dried
strawberries, chocolate-covered almonds,
tobacco, lichen; lined paper, recycled
paper, vellum; two books (by Patty Loew
and by Vine Deloria), *Wisconsin People &
Ideas* magazine, Grass Tex outdoor carpet,
Ho-Chunk baskets, plastic shopping
basket, medicine bottles, nonfunctioning
mobile telephones, and video component
Tree: 14 x 20 ft.; projected images and
other elements: dimensions variable
Courtesy the artists

Donna House and Truman Lowe
Se'e'-t'da-jauh (Since Time), 2006
(detail)
Tree: 14 x 20 ft.; projected images and
other elements: dimensions variable
Courtesy the artists

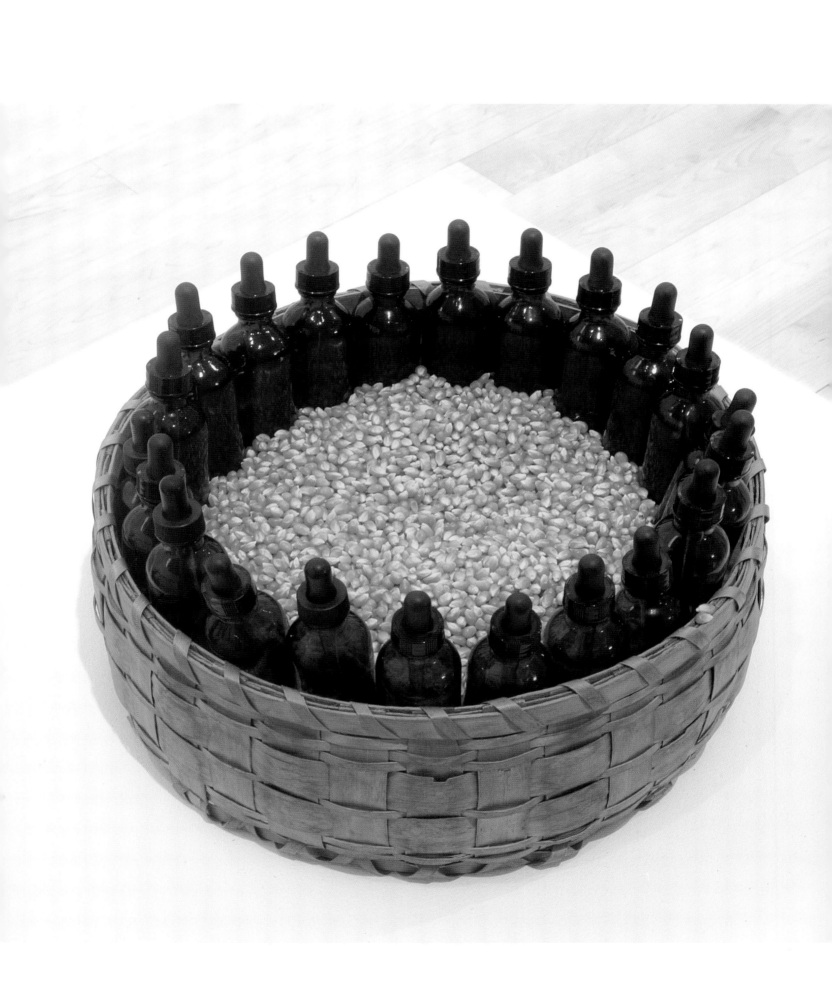

Lee Mingwei
Zhua-Zhou Project, 2006
Metal scaffolding, wooden shelves, canvas
sheets, electric light bulbs, and more
than 50 objects (including a wineglass
containing wishbones and a paper
"Chinese fortune cookie" fortune; a
Wisconsin-theme ceramic plate; a shaped
mirror; a copy of the *New York Times
Cookbook* with all the pages folded back;
and others)
12 ft. x 11 ft. 8 in. x 14 ft.
Courtesy the artist and Lombard-Freid
Projects, New York

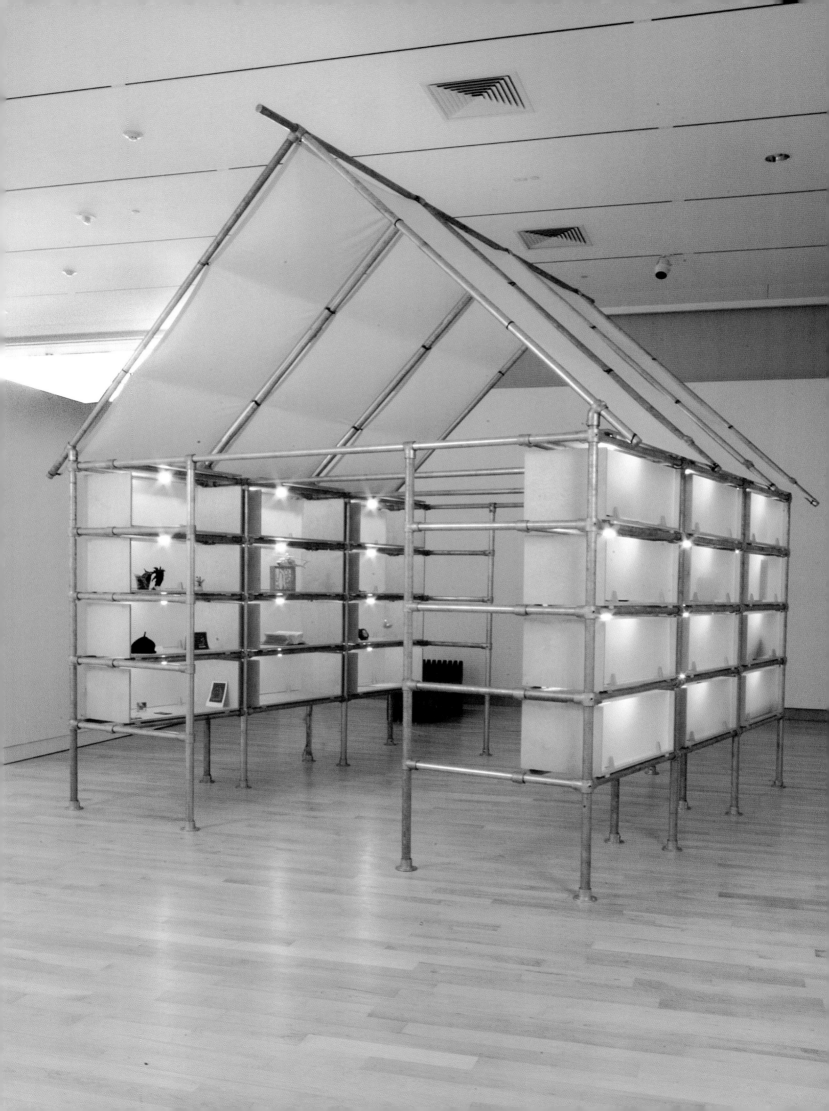

cat. no. 8

Lee Mingwei
Zhua-Zhou Project, 2006
(detail)
A copy of the *New York Times Cookbook*
with all the pages folded back
12 ft. x 11 ft. 8 in. x 14 ft.
Courtesy the artist and Lombard-Freid
Projects, New York

cat. no. 9

Nancy Mladenoff
Undertow, 2005
Oil and spray paint on canvas
84 x 108 in.
Courtesy the artist and Wendy Cooper
Gallery, Chicago

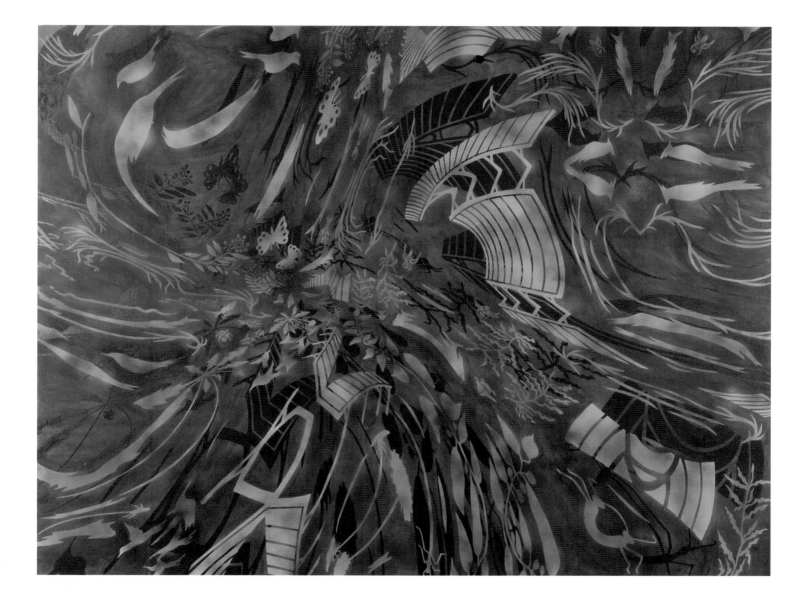

cat. no. 10

Nancy Mladenoff
Spanning Time, 2006
Oil and spray paint on canvas
60 x 78 in.
Courtesy the artist and Wendy Cooper
Gallery, Chicago

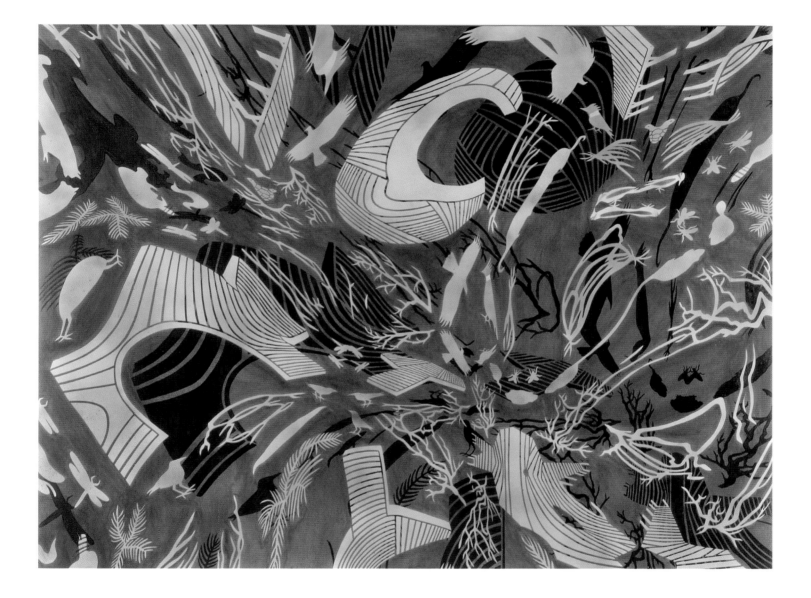

cat. no. 11

Alec Soth
Glyphia, 2005
C-print, 40 x 32 in.
Courtesy the artist, Gagosian Gallery,
New York, and Weinstein Gallery,
Minneapolis

cat. no. 12

Alec Soth
Dock #2, 2005
C-print, 40 x 50 in.
Courtesy the artist, Gagosian Gallery,
New York, and Weinstein Gallery,
Minneapolis

Artist Information

Siah Armajani

Born Tehran, Iran, 1939

Lives and works in Minneapolis, Minnesota

Selected Solo Exhibitions

1998 *Siah Armajani*, Museo Nacional Centro de Arte Reina Sofía, Madrid

1987 *Siah Armajani*, Stedelijk Museum, Amsterdam

1985 *Siah Armajani: Bridges, Houses, Communal Spaces Dictionary for Building*, Institute of Contemporary Art, University of Pennsylvania, Philadelphia

Selected Permanent Public Works

2005 *Floating Poetry Room*, Ijborg, Amsterdam

2003 *Georg Simmel Footbridge*, Strasbourg, France

2000 *Bridge for Iowa City*, Iowa City, Iowa

1997 *Sacco and Vanzetti Reading Room No. 4*, Musée d'Art Moderne et Contemporain, Strasbourg, France

1997 *Bow-Front Balustrade for Washington D.C. National Airport*, Arlington, Virginia

1997 *Three Skyway Bridges for City of Leipzig*, Leipzig, Germany

1996 *Bridge, Tower, Cauldron*, 1996 Centennial Olympics, Atlanta, Georgia

1989 *SkyBridge #2*, Minneapolis, Minnesota

1988 *SkyBridge #1*, Minneapolis, Minnesota (collaboration with Cesar Pelli)

1988 *Irene Hixon Whitney Bridge*, Minneapolis, Minnesota

Selected Group Exhibitions

1998 *The Last Room for Noah Chomsky,* P.S.1 Contemporary Art Center, Long Island City, New York

1997 *Views from Abroad: European Perspectives on American Art*, Museum für Moderne Kunst, Frankfurt

1993 *Differentes Natures: Visions de l'Art Contemporain*, Place de la Défense, Paris

1992 *Century of Sculpture*, Stedelijk Museum, Amsterdam and Nieuwe Kerk Foundation, Amsterdam

1990 *Culture and Commentary: An Eighties Perspective*, Hirshhorn Museum and Sculpture Garden, Smithsonian Institution, Washington, D.C.

Selected Bibliography

Ammann, Jean-Christophe, Siah Armajani, and Margrit Suter. *Siah Armajani*, exh. cat. Basel: Kunsthalle Basel; Amsterdam: Stedelijk Museum, 1987.

Arnason, H. H. *History of Modern Art: Painting, Sculpture, Architecture, Photography*. Upper Saddle River, New Jersey: Prentice Hall, 2004.

Bernard, Christian and Nancy Princenthal. *Siah Armajani: Anarchistics Contributions 1962–1994*, exh. cat. Nice, France: Villa Arson, Centre National d'Art Contemporain, 1994.

Jimenez-Blanco, María Dolores, Alicia Gillida, Nancy Princenthal, et al. *Siah Armajani*, exh. cat. Madrid, Spain: Museo Nacional Centro de Arte Reina Sofía, 1999.

Kardon, Janet. *Siah Armajani: Bridges, Houses, Communal Spaces, Dictionary for Building*, exh. cat. Philadelphia: Institute of Contemporary Art, University of Pennsylvania, 1985.

Lippard, Lucy. *Six Years: The Dematerialization of the Art Object from 1966 to 1972*. New York: Praeger, 1973.

Matthew Buckingham

Born in Nevada, Iowa, 1963

Lives and works in New York City

Selected Solo Exhibitions and Installations

2005 *Traffic Report*, St. Louis Museum of Art, St. Louis, Missouri

2004 *Concentrations 44: Matthew Buckingham, a Man of the Crowd*, Dallas Museum of Art, Dallas, Texas

2003 *A Man of the Crowd*, Museum Moderner Kunst Stiftung Ludwig, Vienna

2002 *Definition*, P.S.1 Contemporary Art Center, Long Island City, New York

2001 *Matthew Buckingham: Video Ab Acht*, Schnitt Ausstellungsraum, Cologne, Germany

2001 *Sandra of the Tuliphouse, or How to Live in a Free State* (collaboration with Joachim Koester), Statens Museum for Kunst, Copenhagen, Denmark; Capecete Projects, Rio de Janeiro, Brazil

1999 *Contemporary Film and Video: Matthew Buckingham,* Moderna Museet, Stockholm, Sweden

Selected Group Exhibitions

2005 *I Beg Your Pardon*, Vera List Center for Art and Politics, New School, New York

2004 *Push the Envelope*, Sparwasser HQ, Berlin

2003 *Territories*, Kunst-Werke Institute for Contemporary Art, Berlin

2003 *Homeland*, Whitney Independent Study Program, CUNY Graduate Center, New York

2003 *Watershed: The Hudson Valley Art Project*, Minetta Brook, Beacon, New York

2003 *Cloudless,* Center for Curatorial Studies, Bard College, Annandale-on-Hudson, New York

2003 *Inscribing the Temporal*, Kunsthalle Exnergasse, Vienna

2001 *Plakardprojekt,* Schnitt Ausstellungsraum, Cologne

2000 *May Day Vienna,* Kunsthalle Exnergasse, Vienna

2000 *La Ville, le Jardin, la Mémoire (La Folie Section),* Villa Medici/Académie Française, Rome

2000 *Greater New York,* P.S.1 Contemporary Art Center, Long Island City, New York

1999 *Caravan,* Astrotel Contemporary Art, Vienna

1999 *The American Century,* Whitney Museum of American Art, New York

1999 *Close-Ups: Contemporary Art and Carl Th. Dreyer,* Nikolaj Contemporary Art Center, Copenhagen

1998 *Nuit Blanche,* ARC Musée d'Art Moderne de la Ville de Paris, Paris

1998 *Something Is Rotten in the State of Denmark,* Museum Fridericianum, Kassel, Germany

1997 *Assorted Confabulations: Fiction + Interference,* Consonni Centro de Prácticas Contemporáneas, Bilbao

1996 *New Histories,* Institute of Contemporary Art, Boston

Selected Awards and Fellowships

2006 Interdisciplinary Artist in Residence, Arts Institute, University of Wisconsin-Madison

2005 External Tutor, Arts Academy in Malmö, Sweden

2004 Henry and Natalie E. Freund Teaching Fellowship, Washington University School of Art, St. Louis, Missouri

2003 DAAD Artist Program, Berlin

2001 New York Foundation for the Arts, Artists Fellowship

1997 Danish Film Institute Film Workshop Production Grant

1996 New York State Council on the Arts Film Production Grant

1992 Art Matters Artist's Fellowship, New York

1990 Apparatus Production Grant, New York

Selected Bibliography

Buckingham, Matthew. "A Man of the Crowd: annotated associations with Edgar Allan Poe's tale *The Man of the Crowd*," in Gregor Neuerer, ed., *Untitled (Experience of Place).* London: Koenig Books Ltd., 2003.

Buckingham, Matthew. *Subcutaneous* (artist's book). New York: Shark Books, in association with Murray Guy gallery, 2001.

Dean, Tacita. "Matthew Buckingham: Historical Fiction." *Artforum*, March 2004.

Heiss, Alanna, Glenn D. Lowry, et al. *Greater New York*, exh. cat. New York: P.S.1 Contemporary Art Center, 2005.

Huck, Brigitte. "Matthew Buckingham, Museum Moderner Kunst Stiftung Ludwig" (review). *Artforum*, January 2004.

Jensen, Lene Crone and Lars Movin. *Close-Ups: Contemporary Art and Carl Th. Dreyer.* Copenhagen, Denmark: Nikolaj Contemporary Art Center, 1999.

Schwendener, Martha. "Matthew Buckingham and Joachim Koester, The Kitchen, New York" (review). *Artforum*, May 4, 2005.

Torp, Marianne. *Sandra of the Tuliphouse, or How to Live in a Free State.* Copenhagen, Denmark: Statens Museum for Kunst, 2001.

Donna House

Diné (Navajo) born to Kinyaa'nii (Towering House People Clan) and Onayotekaono (Oneida) born for A'nowalu (Turtle Clan)
125 winters
Lives on a farm along the Rio Grande in northern New Mexico

Selected Projects

2004 National Museum of the American Indian, Washington, D.C.

Selected Bibliography

Brown, Patricia Leigh. "A Native Spirit Inside the Beltway." *New York Times*. September 9, 2004.

Spruce, Duane Blue. *Spirit of a Native Place*. Washington, D.C.: National Museum of the American Indian and National Geographic Society, 2005.

Truman Lowe

Born in Black River Falls, Wisconsin, 1944

Lives and works in Madison, Wisconsin

Selected Exhibitions

2001 *Remembrance*, Madison Art Center, Madison

1998 *From the Woodlands: Truman Lowe*, Wright Museum of Art, Beloit College, Beloit, Wisconsin

1997 Sculpture Commission for the White House's Jacqueline Kennedy Garden, Washington, D.C.

1996 *Shared Visions: Native American Painters and Sculptors of the Twentieth Century*, Auckland and Wellington, New Zealand

1994 *Truman Lowe: Haga (Third Son)*, Eiteljorg Museum of American Indians and Western Art, Indianapolis, Indiana

1985 *Second Biennial Native American Fine Arts Invitational*, Heard Museum, Phoenix, Arizona

Selected Awards and Fellowships

2005 Wisconsin Academy Fellow, Wisconsin Academy of Sciences, Arts and Letters, Madison

1998 Eiteljorg Fellowhip for Native American Fine Art, Eiteljorg Museum of American Indians and Western Art, Indianapolis, Indiana

1997 Wisconsin Alumni Research Foundation Mid-Career Faculty Research Award, University of Wisconsin-Madison

1994 National Endowment for the Arts Individual Fellowship for Sculpture

Selected Bibliography

Adney, Edwin T., and Howard I. Chapelle. *The Bark Canoes and Skin Boats of North America*. Washington, D.C.: Smithsonian Institution Press, 1983.

Allen, Hayward. *Truman Lowe: Streams*. La Crosse: University of Wisconsin-La Crosse, 1991.

Complo, Jennifer. *Haga (Third Son): Truman Lowe*. Indianapolis: Eiteljorg Museum of American Indians and Western Art, 1994.

Ortel, Jo, and Lucy Lippard. *Woodland Reflections: The Art of Truman Lowe*. Madison: University of Wisconsin Press, 2003.

Lee Mingwei

Born in Taiwan, 1964

Lives and works in New York City and Berkeley

Selected Solo Exhibitions

2006 *The Bodhi Project*, Queensland Gallery of Modern Art, Brisbane, Australia

2004 *Through Masters' Eyes*, Los Angeles County Museum of Art, Los Angeles

2004 *Shueito Legends*, Bunker Museum of Contemporary Art, Kinman, Taiwan

2003 *The Tourist Project*, Projects 80, Museum of Modern Art, New York

2000 *The Living Room Project*, Isabella Stewart Gardner Museum, Boston

2000 *The Sleeping Project*, Lombard-Freid Fine Arts, New York

1998 *Way Stations*, Whitney Museum of American Art, New York

1998 *The Letter Writing Project*, Fabric Workshop and Museum, Philadelphia

Selected Group Exhibitions

2006 *Liverpool Biennial–International Festival of Contemporary Art*, Liverpool

2006 *Echigo-Tsumari Art Triennial*, Echigo-Tsumari, Japan

2005 *Trading Places*, Taipei Museum of Contemporary Art, Taipei

2005 *Elegance of Silence*, Mori Art Museum, Tokyo

2005 *Spice Box Invitational*, Contemporary Jewish Museum, San Francisco

2004 *Whitney Seers Project*, in *Whitney Biennial*, Whitney Museum of American Art, New York

2004 *Fiction.Love—Ultra New Vision in Contemporary Art*, Taipei Museum of Contemporary Art, Taipei

2003 *Limbo Zones*, Taiwan Pavilion in *Venice Biennale*

2003 *Away from Home*, Wexner Center for the Arts, Columbus, Ohio

2003 *We Are the World*, Chelsea Art Museum, New York

2003 *Somewhere Better Than This Place*, Contemporary Art Center, Cincinnati, Ohio

2003 *The Magic Makers*, Des Moines Center of Art, Des Moines, Iowa

2003 *Mind Space*, Ho-AM Art Museum, Seoul, South Korea

2002 *Sitelines*, Mosquito Cinema, Addison Gallery of American Art, Andover, Massachusetts

2001 *Male Pregnancy Project*, Museum of Contemporary Art, Taipei, Taiwan

2001–3 *The Gift: Generous Offerings, Threatening Hospitality*, Centro Arte Contemporanea Palazzo delle Papesse, Siena, Italy (traveling exhibition)

2001 *The Bayberry Bush*, Parrish Art Museum, South Hampton, New York

2000 *The Shrine Project*, in *Taipei Biennial*

2000 *The Living Room*, Isabella Stewart Gardiner Museum, Boston

Selected Residencies and Fellowships

2006 Visiting Artist, Isabella Stewart Gardiner Museum, Boston

2005 Visiting Artist, DanJian University, Taipai, Taiwan

2004 Visiting Artist, Taiwan National Art Academy, Taiwan

2004 Visiting Artist, Columbia University, New York

2004 Visiting Artist, U.C. Irvine, California

2004 Visiting Artist, School of the Museum of Fine Arts, Boston

2003 Marshall S. Cogan Visiting Artist, Harvard University, Cambridge, Massachusetts

Selected Bibliography

Barron, Stephanie and J. Keith Wilson. *Lee Mingwei's "Through Masters' Eyes."* Los Angeles: Los Angeles County Museum of Art, 2004.

Cheng, Scarlet. "A Master Revisited." *Los Angeles Times*, May 9, 2004.

Cotter, Holland. "Lee Mingwei—'Projects 80.'" *New York Times*, November 21, 2003.

Hyde, Lewis and Gross, Jennifer. *Lee Mingwei: The Living Room*. Boston: Isabella Stewart Gardner Museum, 2000.

Karson, Kay. "To Take Part in the Art, You Sleep with the Artist." *New York Times*, November 5, 2000.

Larson, Kay. "Healing Power of Art." *New York Times*, November 15, 1998.

Myles, Eileen. "Mingwei Lee." *Art in America*, November 1997.

Sozanski, Edward. "Letter-writing as Art and a Devotional." *Philadelphia Inquirer*, November 6, 1998.

Thea, Carolee. "Lee Mingwei." *Sculpture Magazine*, March 2002.

Weisgall, Deborah. "Lee Mingwei's 'Please Make Yourself at Home in the Art.'" *New York Times*, April 23, 2000.

Nancy Mladenoff

Born in Wakefield, Michigan, 1957

Lives and works in Madison, Wisconsin

Selected Exhibitions

2005 *Carry On*, Feigen Contemporary, New York

2004 *draw/drawing*, Gallery 32, London

2003 *hush, you mushrooms*, Wendy Cooper Gallery, Chicago

2003 *Centro-Oestes: Nucleo Madison*, Museu de Arte de Brasília, Brasilia, Brazil

2002 *Natural History*, Aron Packer Gallery, Chicago

2002 *On Nature*, Milwaukee Art Museum, Milwaukee

Selected Grants, Honors, and Residencies

2005 Cultural Exchange Station in Tábor (CESTA), Czech Republic

2005 Lademoen Kunster Verkstedet, Trondheim, Norway

2004 Wisconsin Arts Board Fellowship Award, Madison

2000 Fred Kraus Memorial Award, 20th Annual Faber Birren National Color Award Exhibition, Stamford Art Center, Stamford, Connecticut

1996 Wisconsin Arts Board Fellowship Award, Madison

1996 Creative Artist Fellowship, Dane County Cultural Affairs Commission, Wisconsin

Selected Bibliography

Ayres, Paul W. "Downtown Gallery Attracts International Artists." *Tampa Tribune,* June 26, 2003.

Cassidy, Victor. "Art Chicago 2004." *artnet.com,* May 7, 2004.

Frank, Nicholas. " Chicago, Illinois." *ART PAPERS,* September/October, 2004.

Golub, Adrienne M. "Truth or Reality." *Weekly Planet,* August 28, 2003.

Graeber, Laurel. "Frogs, Myths & Adolescence." *New York Times Book Review*, October 9, 1990.

Henry, Amanda. "Art au naturel." *Wisconsin State Journal,* October 24, 2003.

Maciel, Nahima. "Fervilhante Center." *Correio Braziliense (*Brazil), July 16, 2003.

McCue, Frances. "'Hysterical' Women Artists Capture Scenes from the New World of Comics." *Seattle Times,* November 22, 2002.

Odita, Odili Donald. "Focus-Pocus." *artUS* , November/December 2003.

Raven, Arlene. "ABC No Lady." *Village Voice*, June 19, 1990.

Rees, Christina. "Consider the Copycat." *Dallas Observer,* January 2000.

Rhem, James. "Narrative Abstractions: The Twelve Months." *New Art Examiner*, March 1994

Smith, Jennifer. "When Art Meets Nature." *Isthmus* (Madison, Wisc.), May 17, 2001.

Waldkunstpfad-Recherche. Darmstadt, Germany, 2002.

Workman, Michael. "Chicago: Navy Pier." *contemporary,* no. 65, 2004.

Zavitas, Steven T. *New American Paintings.* Boston: Open Studios Press, 2002.

Alec Soth

Born in Minnesota, 1969

Lives and works in Minneapolis, Minnesota

Selected Exhibitions

2006 *Sleeping by the Mississippi*, Des Moines
Art Center, Des Moines, Iowa

2006 *NIAGARA*, Gagosian Gallery, New York

2006 *Beyond the Portrait*, TH InSide, Milan, Italy

2006 *Picturing Eden*, George Eastman House,
Rochester, New York

2006 *ClickDoubleClick*, Haus der Kunst, Munich

2006 *Deutsche Börse Photography Prize 2006*,
Photographers' Gallery, London

2005 *Regarding the Rural*, MassMoCA, North
Adams, Massachusetts

2005 *New Photography: McKnight Fellows
2004–5*, Katherine Nash Gallery,
Minneapolis, Minnesota

2005 *Portraits*, Minneapolis Institute of Arts,
Minneapolis, Minnesota

2004 Selections from *Sleeping by the
Mississippi*, Weinstein Gallery,
Minneapolis, Minnesota

2004 Selections from *Sleeping by the
Mississippi*, Stephen Wirtz Gallery, San
Francisco

2004 Selections from *Sleeping by the
Mississippi*, Yossi Milo Gallery, New York

2004 *Whitney Biennial*, Whitney Museum of
American Art, New York

2004 *26th Bienal de São Paulo*, Pavilhão Ciccillo
Matarazzo, São Paulo, Brazil

2003 *Sleeping by the Mississippi*, Museum of
Contemporary Photography, Chicago

2003 *Sleeping by the Mississippi*, Weitman
Gallery of Photography, Washington
University, St. Louis, Missouri

Selected Awards and Fellowships

2005 The Photographers' Gallery Deutsche
Börse Photography Prize, Finalist

2004 McKnight Photography Fellowship

2003 Santa Fe Prize for Photography

2001 Minnesota State Arts Board

2001 Minneapolis College of Art + Design/
Jerome Fellowship

2001 Jerome Travel and Study Grant

1999 McKnight Photography Fellowship

Public Collections

Brooklyn Museum of Art, Brooklyn, New York

Carleton College, Northfield, Minnesota

Israel Museum of Contemporary Art, Jerusalem,
Israel

Los Angeles County Museum of Art, Los Angeles

Madison Museum of Contemporary Art, Madison

Memphis Brooks Museum of Art, Memphis,
Tennessee

Minneapolis Institute of Arts, Minneapolis,
Minnesota

Museum of Contemporary Photography, Chicago

Museum of Fine Arts, Houston, Texas

Ogden Museum of Southern Art, New Orleans

San Francisco Museum of Modern Art, San
Francisco

Walker Art Center, Minneapolis, Minnesota

Whitney Museum of American Art, New York

Selected Bibliography

Cotter, Holland. "Alec Soth." *New York Times*,
April, 16 2004.

"Goings On About Town: Photography." *New
Yorker*, March 29, 2004.

Kimmelman, Michael. "Touching All Bases at the
Biennial." *New York Times*, March 12, 2004.

Lacayo, Richard. "Major Art Attack." *Time*, March
29, 2004.

Linked to the Future: Minneapolis and St. Paul.
Photographs by Alec Soth. Memphis: Towery
Publishing, Inc., 1997.

Meyers, William. "Photography: the Newest
Eyes." *New York Sun,* April 15, 2004.

Raymond, Jonathan. "Reviews: Alec Soth."
Artforum, Summer 2004.

Rosenberg, Karen. "A River Runs Through It."
New York Magazine, March 22, 2004.

Smith, Roberta. "Southern Photography, Inspired
by a Yankee." *New York Times,* December 4,
2004.

Soth, Alec. "The Making of Parts" (photoessay).
Granta no. 89, April 15, 2005.

Tucker, Anne Wilkes and Patricia Hampl. *Sleeping
by the Mississippi*. Göttingen, Germany: Steidl,
2004.

Vantage Points: Campus as Place. Photographs
by Alec Soth, Beth Dow, Chris Faust. Northfield,
Minnesota: Carleton College Press, 2002.

Exhibition Checklist

Siah Armajani (American, b. Iran, 1939)

Emerson's Parlor, 2005
Laminated wood, glass, plywood, metal bed
frames, mattress and pillow, white and black
paint, wool, straw, black felt curtain, diamond-
shaped mirror, coat, and hat
22 x 20 x 10 ft.
Courtesy the artist and Senior & Shopmaker
Gallery, New York

Matthew Buckingham (American, b. 1963)

Behind the Terminal Moraine, 2006
16mm film projection with oscillating mirror
Dimensions variable
Courtesy the artist and Murray Guy Gallery,
New York

Donna House (Diné [Navajo] born to
Kinyaa'nii [Towering House People Clan], and
Onayotekaono [Oneida] born for An'owalu
[Turtle Clan], 125 winters)

Truman Lowe (Ho-Chunk, b. 1944)

Se'e'-t'da-jauh (Since Time), 2006
Douglas fir; bark of birch, maple, and white oak;
branches of dogwood; willow, wild rice, white
corn, yellow corn, blue corn, dried cranberries,
dried strawberries, chocolate-covered almonds,
tobacco, lichen; lined paper, recycled paper,
vellum; two books (by Patty Loew and by Vine
Deloria), *Wisconsin People & Ideas* magazine,
Grass Tex outdoor carpet, Ho-Chunk baskets,
plastic shopping basket, medicine bottles,
nonfunctioning mobile telephones, and video
component
Tree: 14 x 20 ft.; projected images and other
elements: dimensions variable
Courtesy the artists

Lee Mingwei (Taiwanese-American, b. 1964)

Zhua-Zhou Project, 2006
Metal scaffolding, wooden shelves, canvas
sheets, electric light bulbs, and more than
50 objects (including a wineglass containing
wishbones and a paper "Chinese fortune cookie"
fortune; a Wisconsin-theme ceramic plate; a
shaped mirror; a copy of the *New York Times
Cookbook* with all the pages folded back; and
others)
12 ft. x 11 ft. 8 in. x 14 ft.
Fabricated by Eric Sparks and designed by
Stephan Freid
Courtesy the artist and Lombard-Freid Projects,
New York

Nancy Mladenoff (American, b. 1957)

Vortex, 2005
Oil and spray paint on canvas
72 x 90 in.
Courtesy the artist and Wendy Cooper Gallery,
Chicago

Suspension, 2005
Oil and spray paint on canvas
84 x 108 in.
Courtesy the artist and Wendy Cooper Gallery,
Chicago

Undertow, 2005
Oil and spray paint on canvas
84 x 108 in.
Courtesy the artist and Wendy Cooper Gallery,
Chicago

Spanning Time, 2006
Oil and spray paint on canvas
60 x 78 in.
Courtesy the artist and Wendy Cooper Gallery,
Chicago

Foreshadow, 2006
Oil and spray paint on canvas
58 x 96 in.
Courtesy the artist and Wendy Cooper Gallery,
Chicago

Alec Soth (American, b. 1969)

Anna, 2005
C-print
40 x 32 in.
Courtesy the artist, Gagosian Gallery,
New York, and Weinstein Gallery, Minneapolis

Apples, 2005
C-print
40 x 32 in.
Courtesy the artist, Gagosian Gallery,
New York, and Weinstein Gallery, Minneapolis

Glyphia, 2005
C-print
40 x 32 in.
Courtesy the artist, Gagosian Gallery,
New York, and Weinstein Gallery, Minneapolis

Journal, 2005
C-print
40 x 32 in.
Courtesy the artist, Gagosian Gallery,
New York, and Weinstein Gallery, Minneapolis

Stephen, 2005
C-print
50 x 40 in.
Courtesy the artist, Gagosian Gallery,
New York, and Weinstein Gallery, Minneapolis

Dock #1, 2005
C-print
40 x 50 in.
Courtesy the artist, Gagosian Gallery,
New York, and Weinstein Gallery, Minneapolis

Dock #2, 2005
C-print
40 x 50 in.
Courtesy the artist, Gagosian Gallery,
New York, and Weinstein Gallery, Minneapolis

Dock #3, 2005
C-print
40 x 50 in.
Courtesy the artist, Gagosian Gallery,
New York, and Weinstein Gallery, Minneapolis

Phil, 2005
C-print
40 x 32 in.
Courtesy the artist, Gagosian Gallery,
New York, and Weinstein Gallery, Minneapolis

MMoCA Staff

Director's Office
Stephen Fleischman, *Director*
Jennifer Homes, *Assistant to the Director*

Administrative Department
Michael Paggie, *Business Manager*
Judy Schwickerath, *Accountant*
Sarah Q. Miner, *Receptionist*

Curatorial Department
Jane Simon, *Curator of Exhibitions*
Sheri Castelnuovo, *Curator of Education*
Marilyn Sohi, *Registrar*
Janet Laube, *Education Associate*
Emily Schreiner, *Curatorial Assistant*
Stephanie Hawley, *Assistant Registrar*
Shannon Kavanagh, *Education Assistant*
Doug Fath, *Preparator*

Development Department
Nicole Allen, *Director of Development*
Katie Kazan, *Director of Public Information*
Susan Lang, *Director of Volunteer Services*
Betty Merten, *Office Assistant*

Technical Services Department
Dale Malner, *Technical Services Supervisor*

Public Operations
James Kramer, *Director of Public Operations*
Katie Kinkaid, *Manager of Public Operations*
Andrew Ballard, *Public Operations Assistant*
Kim Davis, *Public Operations Assistant*
Iris Stevenson, *Public Operations Assistant*
Andy Ballard, *Gallery Attendant*
Sandy Bassett, *Gallery Attendant*
Adam Erdman, *Gallery Attendant*
Katrina Harms, *Gallery Attendant*
Heather Huffman, *Gallery Attendant*

Allison Kyle, *Gallery Attendant*
Chris Martin, *Gallery Attendant*
Tia Murray, *Gallery Attendant*
Abraham Ritchie, *Gallery Attendant*
Rachael Rogers, *Gallery Attendant*
Mary Savig, *Gallery Attendant*
Amanda Schmitt, *Gallery Attendant*
Bethany Scott, *Gallery Attendant*
Megan Soma, *Gallery Attendant*

Gallery Shop
Leslie Genszler, *Museum Store Manager*
Laurie Saager, *Museum Store Assistant Manager*
Paul Baker Prindle, *Museum Store Associate*
Ann Seiser, *Museum Store Associate*
Evgenia Goryshina, *Museum Store Assistant*
Lanny Wong, *Museum Store Assistant*